Improbable
Libraries

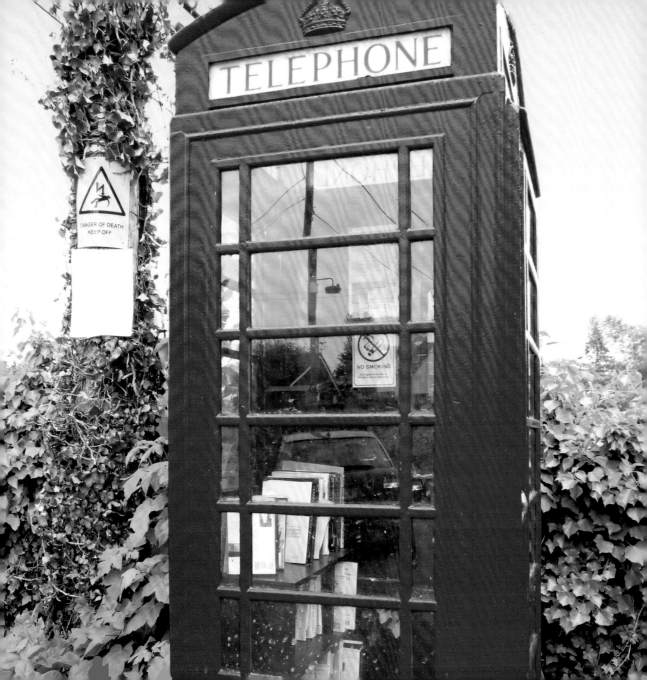

Improbable Libraries

A Visual Journey to the World's Most Unusual Libraries

ALEX JOHNSON

The University of Chicago Press
Chicago

**To my mother and father,
Wilma, Thomas, Edward and Robert,
with whom I have shared many happy
times in libraries around the world
over the past 45 years.**

The University of Chicago Press, Chicago 60637
© 2015 by Alex Johnson
All rights reserved. Published 2015.
Printed and bound in China by C & C Offset Printing Co. Ltd

24 23 22 21 20 19 18 17 16 15 1 2 3 4 5

ISBN-13: 978-0-226-26369-4 (cloth)

Published by arrangement with Thames & Hudson Ltd., London.

Library of Congress Cataloging-in-Publication Data

Johnson, Alex, 1969– author.
 Improbable libraries : a visual journey to the world's most unusual libraries / Alex
Johnson.
 pages : illustrations ; cm
 Includes bibliographical references.
 ISBN 978-0-226-26369-4 (cloth : alk. paper) 1. Libraries—Miscellanea. 2. Library
architecture—Miscellanea. 3. Curiosities and wonders. 4. Libraries—Pictorial works. 5.
Library architecture—Pictorial works. I. Title.
 Z662.J64 2015
 027—dc23
 2014035714

Page 1: PRODUCTURA's A47 Mobile Art Library
in a large converted truck, Mexico City.

Page 2: In Hampshire, England, Longstock Parish Council
has turned a former telephone box into a miniature local library.

CONTENTS

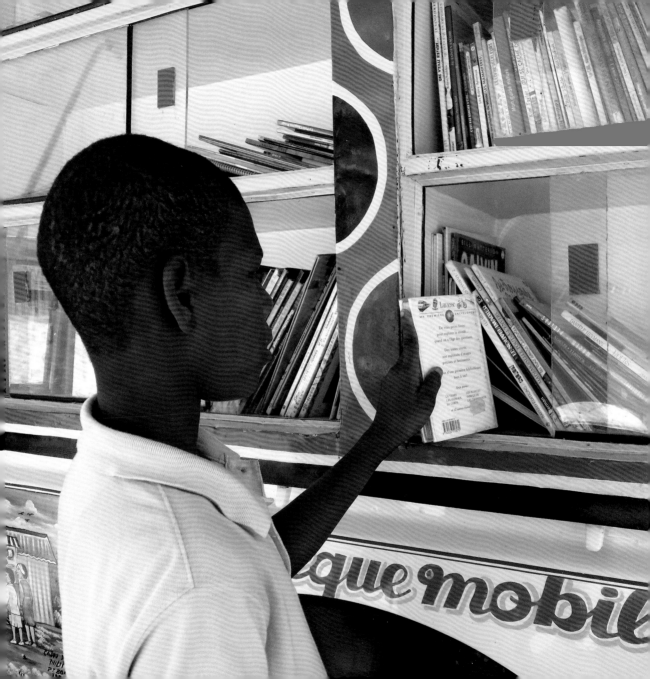

INTRODUCTION

DOES YOUR LIBRARY arrive at your home on an elephant? Perhaps it floats down the river? Is it in your local telephone box, rail station, park – or even in your own back garden?

Librarians have a long history of overcoming geographic, economic and political challenges to bring the written word to an eager audience, they continue to live up to that reputation today, despite the rapid, sweeping changes in how we read and share books in the 21st century. *Improbable Libraries* explores this new library revolution, along with the work of the many architects, designers, educators, artists and activists who are breaking the mould to bring the written word to people everywhere.

Part of the change is architectural. Instead of the stately monolithic structure in the centre of town with which we are most familiar, your local library might now be anything from a temporary pop-up to an imaginative architectural masterpiece resembling a shelf of books or the inside of an iceberg. Meanwhile, ingenious architects and designers are transforming private home and hotel libraries with outdoor seating, flat-pack technology – and even hammocks.

The shift is also technological, reflecting the increased use of mobile apps and digital technology to bring books to a wired world, although many of the libraries in this book still rely on people lugging traditional print books around. But there is also a sense that the very concept of a library is evolving: many of these libraries operate on principles that differ fundamentally from the workings of most traditional public and university libraries. Some, for example, have no membership or

BiblioTaptap
The third bookmobile in the BiblioTaptap project in Haiti was paid for via a crowdfunding campaign. The project name comes from Haiti's 'taptaps', the ubiquitous shared taxis.

identification requirements, and some do not even ask that the books be returned.

This brave new world of nontraditional libraries seems to work, at least in part, because it puts people at the centre of a more collaborative process. Many of the featured libraries rely on their users' honesty and goodwill when it comes to returning borrowed books. Incidents of library vandalism reported to me by the librarians as I put this book together were, happily, almost nonexistent and very few volumes of the millions available had been stolen.

Library designers are taking this shift in the idea of library 'ownership' on board. All these new libraries offer far more than simple collections of books. Many function as community centres, and assist their members in overcoming economic, social and geographical barriers. Others provide an unexpected dose of culture for commuters, beachgoers, café customers, and even prisoners. Some are eccentric works of art or masterpieces of modern design in their own right. All aim to make books more widely accessible and enjoyable than ever.

The vast majority of the smaller libraries in this book owe their existence to a single person, a 'librarian' with an unstoppable vision. Hernando 'Nanie' Guanlao has been running his personal public library Reading Club 2000 for more than a decade in Manila, Philippines. Originally set up to honour his parents' memory, the initial stock of 100 books set up on the pavement outside his home has now grown to several thousand. Like many of the libraries featured in the following pages, Guanlao's library does not require any form of membership or identification. Passersby can 'borrow' as many books as they want and bring them back whenever they feel like it. Or, indeed, just keep them.

Meanwhile, in San Francisco, Kristina Kearns has set up and runs Ourshelves, a private members' library put together by local authors and readers who want to share their favourite titles, which are often not

Reading Club 2000
Manila's Reading Club 2000 on Balagtas Street was set up and is run by local activist Hernando Guanlao, whose motto is: 'A book should be used and reused. It has a life, it has a message.'

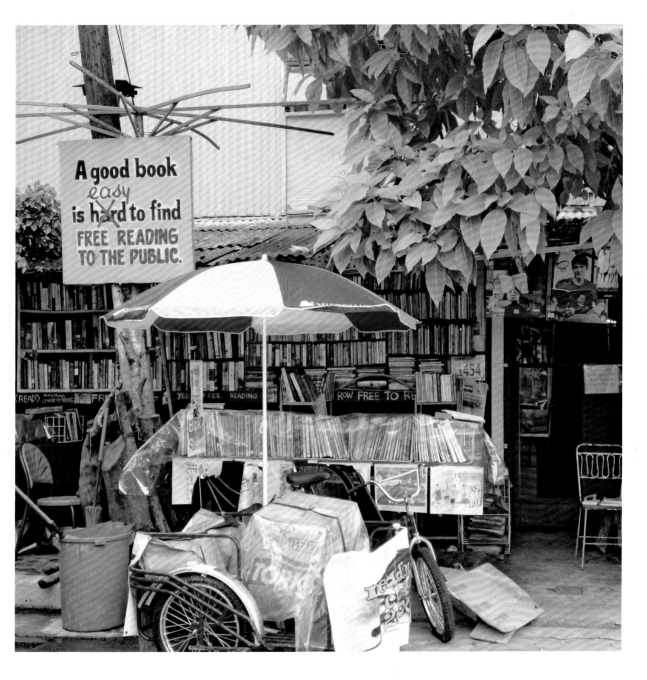

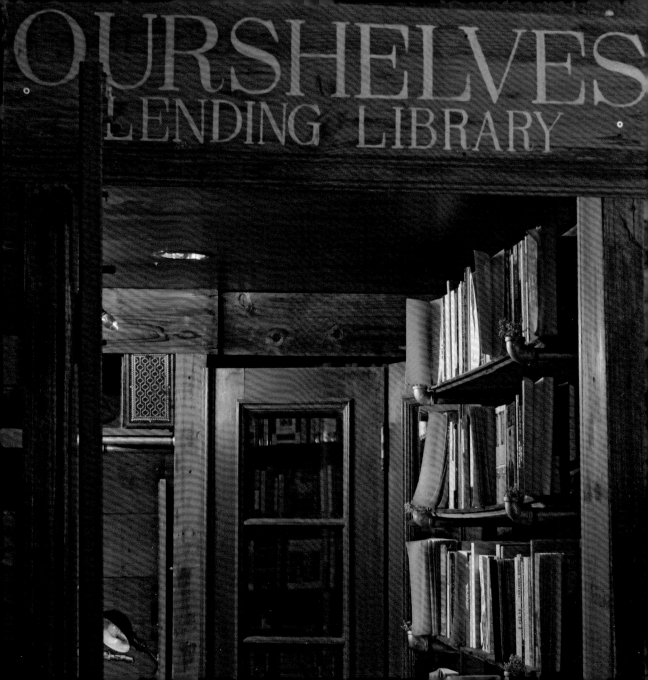

available elsewhere because of price or scarcity. While no one is refused the chance to borrow a book for lack of funds, members' fees are used to put together free libraries in the city that serve women and children in protective housing, older people and anyone with limited access to the public libraries.

Other libraries come into being to meet very specific needs, such as the Story Tower built by Latvian design students as a temporary replacement for a local public library that had been closed for refurbishment, or the seasonal library ships that carry books to remote coastal areas in Norway and Finland. Or the Libraries Without Borders' BiblioTaptap bookmobiles in Haiti, which offer reading material around the country following a recent series of natural disasters that destroyed many libraries and left thousands of people homeless. Occupy Wall Street protesters founded the People's Library in Zuccotti Park during their September 2011 campaign in Lower Manhattan. At its height, the library held 5,500 books and musician Patti Smith even provided a free tent to help when the weather turned bad.

Just as commentators have written off the future of the printed book, there have been many obituaries for the traditional bricks-and-mortar library. Regardless of the ultimate fate of the printed book, the reports of the imminent death of the library as a physical entity seem to have been greatly exaggerated. Bookless digital public libraries are already starting to appear, the first in San Antonio, Texas, where lines of bookshelves have been replaced by e-readers, computer stations, laptops and tablets. The wholly electronic library projects trialled in airports and rail stations have been most successful when, like the libraries at Philadelphia Airport and Amsterdam Airport Schiphol, they also include a comfortable designated physical space in which people can sit and read together.

Ourshelves
Founder Kristina Kearns describes the Ourshelves lending library in San Francisco as an 'open artistic experiment', based on the concept that art should not be separate from the community but affordable and available to all.

The simple truth is that, like Roald Dahl's character Matilda, people just like going to libraries. Indeed, going to the library is like getting a pay rise, according to a survey conducted in 2014 by the Department for Culture, Media and Sport in the UK. The survey, which attempted to quantify how happy various different activities make us, showed that while dancing and swimming nearly always cheer us up, so does going to the library. So much, in fact, that the uplift it gives people is apparently equivalent to getting a £1,359 pay rise!

This book is a celebration of the fact that libraries still enjoy a central place in our society, and that 'librarians' will always beat the odds to bring books to readers. From the rise of the egalitarian international Little Free Library movement (motto: 'Take a book, return a book') to the growth in luxury hotel libraries; whether you're at a subway station in Chile, on a riverboat in Laos, in a yurt in Mongolia, or without ever leaving home at all – you can still, happily, find just the right book waiting to be read.

Occupy library
The People's Library, set up in New York City as part of the Occupy Wall Street movement in 2011, was destroyed in a police raid but has inspired similar libraries at other 'Occupy' protests in the US and Europe.

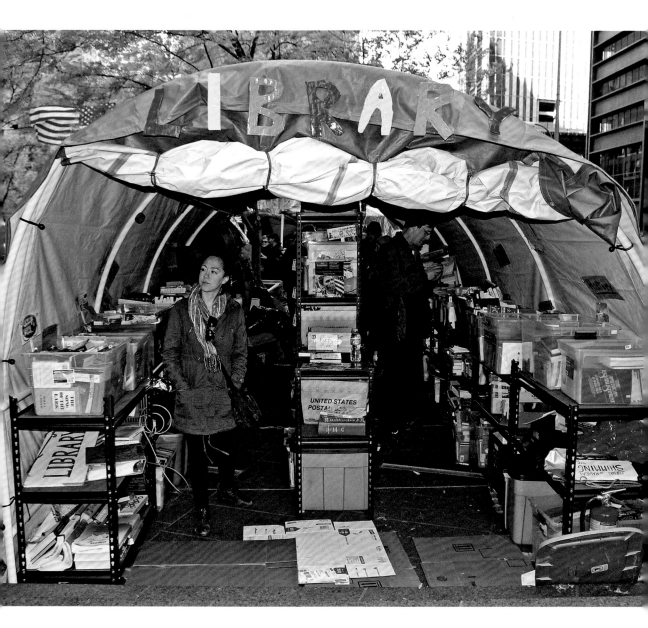

1.
Libraries on the Move

We lead busy lives in the 21st century, and spend much of them travelling: at home and abroad; in planes, trains and automobiles; for work; to visit friends and family; or simply for pleasure. While this makes it difficult to find time to visit a traditional bricks-and-mortar library, there are plenty of innovative new libraries catering for those on the move who also want something decent to read.

Libraries for travellers are by no means a recent invention. In the early 16th century trunks stuffed with books accompanied Henry VIII on his official travel around England; his French royal contemporary Francis I had two travelling chests of books containing works by Appian, Justinus and Thucydides, among others. In the early 17th century, the English legal antiquarian and MP William Hakewill commissioned several lovely travelling libraries as gifts for friends and patrons. These libraries were shaped like large books, which opened to reveal three shelves of vellum-bound Latin classics in miniature editions. Equally ornate Chinese travelling bookcases made of prized *huanghuali* (yellow flowering pear) wood also survive from the early 17th century.

In the 21st century, the traveller's bookcase has given way not simply to the ubiquitous e-book reader, but also to a wide range of library facilities in airports, train stations, and even trains and taxis themselves. Airports in particular have picked up on the need to provide something other than acres of shops for those passing through. In the US, the Kansas State Library collaborated with local airports to provide e-books to travellers via its 'Books on the Fly' campaign. QR codes on cards were distributed around the airports; Kansas residents could scan them to download e-books via the State Library eLending service. Travellers without Kansas library membership were directed to a special Project Gutenberg site where they could download public domain titles. In a similar project, Philadelphia International Airport has made the Free Library of Philadelphia's electronic resources available to airport customers via a Virtual Library Hot Spot on the walkway between Terminals D and E. The 'library space' is fitted out with comfortable lounge chairs, and book-spine graphics are arranged throughout the area, adding to the atmosphere. Travellers in the virtual reading room can log on to the airport's free wi-fi and access the

Hakewill's travel library
The books in this 17th-century case commissioned by William Hakewill are arranged in three categories: theology and philosophy, history, and poetry.

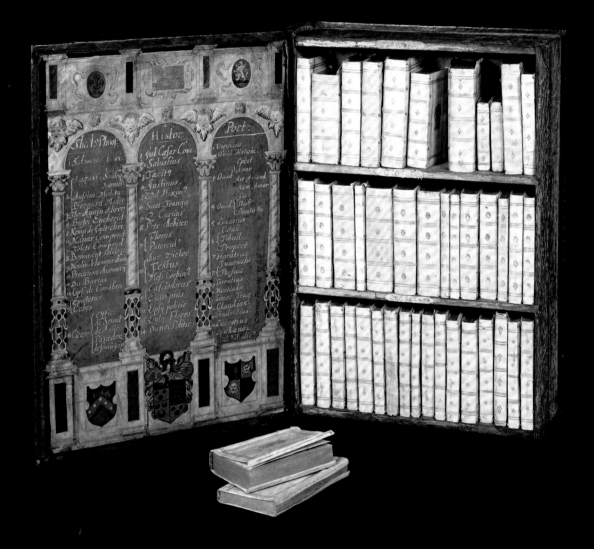

library's 30,000-strong e-book catalogue and more than 1,000 author podcasts. The service is free for local residents but out-of-towners must pay a small fee.

The world's first permanent airport library opened in 2010 at Amsterdam Airport Schiphol. It is operated by the nonprofit organization ProBiblio, which supports Dutch public libraries, and now stocks around 1,250 books including works of Dutch fiction translated into some 30 languages, as well as several iPads with digital content focused on Dutch culture. It is not a circulating library, however: all books must be read on site.

ProBiblio has also opened a library in the Haarlem train station. The library, which is called De Bibliotheek op het station (The Library at the Station), is set up like a retail shop with most of the book covers on the shelves facing out. The space is split into several distinct zones, including an express service area where customers can return a book, pick a new one and check it out in less than 30 seconds. Another has a display table presenting books mentioned recently in national media, and a third area features bestsellers. Seats, a reading table and coffee and tea are also available. Normal city library cards cannot be used; commuters must buy an annual membership or pay on an item-by-item basis, and fines are charged for late returns.

There is also a thriving library network in subway stations. Chile was the first country to introduce a library service on its underground train network. Established in 1996, its Bibliometro service now lends thousands of books to travellers at stations throughout the network and is effectively the largest public library in the country. Other countries such as Spain and Colombia have followed suit, installing glass-fronted Bibliometro kiosks where travellers can borrow books and return them to any kiosk in participating stations.

Even on board a train, you don't have to leave bookish pursuits behind. In Spain, Catalan Government Railways and Random House collaborated on an experimental project called BiblioTren, which turned train carriages into a cross between virtual libraries and e-book shops. Posters of book covers were displayed in the trains. Each cover bore a QR code that enabled riders with smartphones to read the first chapter of the book. Once they had finished reading, they received a link showing where the entire book could be bought, either online as an e-book or in print form from smaller independent bookshops. Vodafone Romania ran a similar experiment at Victoriei rail

station in Bucharest, and students from the Miami Ad School have proposed another poster-based library project to operate on New York City subways.

Taxis, too, are starting to offer passengers something to read during the journey. The Bibliotaxi service run by Easy Taxi began in São Paulo and now operates in 25 other Brazilian cities, as well as in Chile, Colombia and Peru. Books are offered in sleeves hanging on the back of the driver's seat; riders can sign them out in a note-book and take them home, returning them to any other taxi in the scheme or at other locations around the city. Bookstore chain Saraiva has donated 80,000 books to the library, which is now available in c. 50,000 taxis throughout South America. A digital version of Bibliotaxi is on the way via a mobile app.

In Tel Aviv, a rest and a read is available at the Garden Library in Levinsky Park near the city's central bus station. The library functions as an important social hub and community centre for another group of people in transit: newly arrived migrants and asylum seekers.

Business travellers and tourists were among the earliest adopters of e-books read on tablets. Intriguingly, however, this trend has coincided with a renaissance in hotel libraries stocked with traditional printed books, whose tactility seems to be welcomed by travellers who have already spent hours peering at electronic screens during their journeys. For hotel managers, these libraries are proving an effective way to increase revenue from hotel bars and restaurants, since they entice guests to spend more time – and therefore money – within the hotel itself.

The NoMad Hotel in New York is one of a growing number of hotels that recognize the importance of a good library in addition to their more traditional amenities. Its Library Dining Room holds a collection of 3,500 books selected (by Thatcher Wine of Juniper Books) to resemble that of the private reading salon of an eccentric, well-travelled millionaire, with titles on topics ranging from New York history to mysticism, philosophy and cocktails.

These new hotel libraries are usually a reflection of an individual hotel's character and ethos. True to its name, The Library resort in Koh Samui, Thailand, by architect and interior designer Tirawan Songsawat, has a very white, minimalist reading room next to the pool and beach. Another Thai resort, Soneva Kiri in Koh Kood, has a fantastic library for younger guests in its Children's Activity and Education Center, a bamboo dome intended to resemble a manta ray.

In some cases, the library is not simply another amenity on offer, but a central feature

of the hotel. The Radisson Blu Edwardian in Guildford, England, which hosts author events as part of the annual Guildford Book Festival, has an eye-catching floor-to-ceiling library in the centre of its lobby. The design, inspired by the works of local author Lewis Carroll, features a strangely crooked and unclimbable ladder with two rungs covered by a Perspex slab reading 'Library staff only'. Other hotels have gone even further in their library theming and décor. Each of the ten guest floors at The Library Hotel in New York focuses on a single category in the Dewey Decimal System, while each of the 60 rooms features a collection of books on a specific topic within that category.

Gladstone's Library in Hawarden, Wales, one of the few Grade 1-listed buildings in Wales, has gone a step further and markets itself not merely as accommodation with a nice collection of books thrown in, but as a 'residential library'. It was founded by British prime minister William Gladstone in 1889 as a scholarly research library. Gladstone endowed it with £40,000 and more than 32,000 of his own books, many of which he personally transported from his home to the library by wheelbarrow. The hotel–library also has a writer-in-residence scheme and runs an extensive programme of courses and events. There are now over 200,000 volumes on theology, history, philosophy, classics, art and literature, as well as important collections of manuscripts, including much of Gladstone's own correspondence.

Gladstone's Library is one of an elite group of 'literary' hotels that have a sustained involvement not only in their own libraries, but also in literary culture at large. The Ambassade Hotel in Amsterdam has a collection of more than 3,000 signed first editions, reflecting its long-standing relationship with Dutch and international publishing houses. 'This started in the 1970s when visiting publishers decided to stay at the Ambassade and also booked in their authors who were here to promote their Dutch book translations,' explains Eelco Douma, the hotel's reservations manager and librarian. La Mamounia in Marrakech even runs an annual literary prize, Le Prix Littéraire de La Mamounia, which aims to encourage and promote French–Moroccan literature. All nominated books are automatically added to the hotel library's collection.

For other hotel libraries, choosing and sourcing the selection of books on offer can be quite a job. Partnerships with publishing houses are one solution. In the US and Canada, Country Inns and Suites, with 447 hotels, runs

a scheme with Penguin Random called the
Read It and Return Lending Library. Guests
are able to borrow novels and children's books
by Random House authors and subsequently
return it to another participating hotel
location. At the Trump Soho in New York,
Taschen provides a range of its art volumes for
library guests to peruse.

Other hotel library collections are chosen
by local bookshops, but there is also a growing
niche industry in outsourcing the work to
an expert such as Ultimate Library, which
is based in London, and was founded by
Philip Blackwell (formerly a director of his
family's Blackwell publishing and bookshop
empire). Ultimate Library has put together
bespoke libraries for dozens of international
hotels and resorts, ranging from traditional
English hotels, such as the Magdalen Chapter
in Exeter and the Montpellier Chapter
in Cheltenham, to the rather hip-looking
Carlisle Bay resort in Antigua, whose library
is illuminated with pastel fibre-optic lights.
Incorporating both new and secondhand books,
each selection takes into account the property's
location, average length of guest stay, other
amenities and local interests.

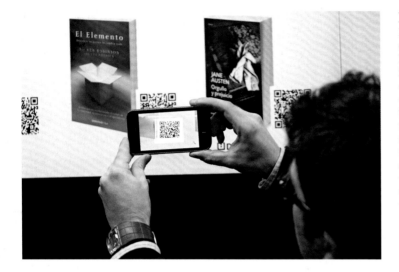

BiblioTren

BiblioTren was an experimental electronic library project on a railway in Catalonia, Spain. QR codes on the windows in ten carriages in ten different trains helped commuters use their mobile phones for something other than checking their email. Literary fiction accounted for 40% of the titles that were downloaded, and Gabriel García Márquez was the most popular author.

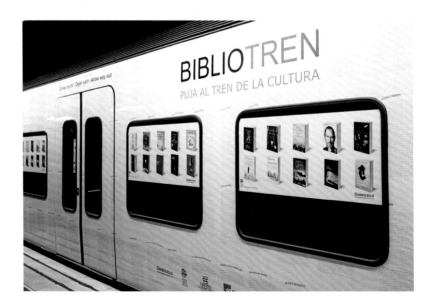

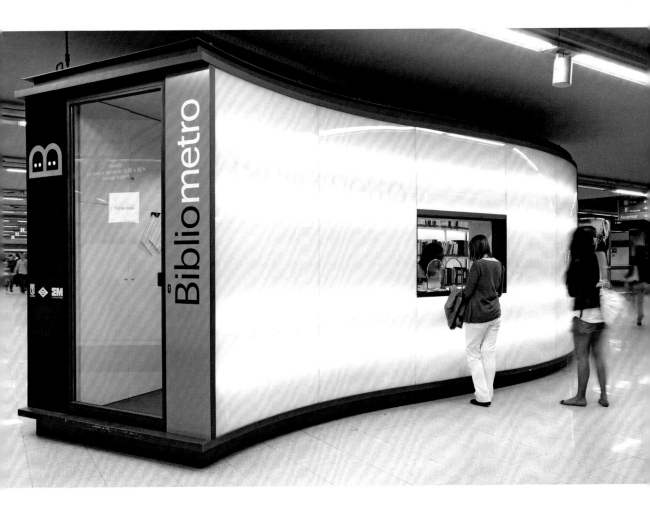

Bibliometro Madrid

The Bibliometro units at subway stations around Madrid are open weekdays from 1.30 PM to 8 PM. Each offers around 800 titles and readers can borrow two books for two weeks, with an option to renew. Books can be returned to any station unit or left in collection boxes.

Bibliometro Santiago

The Chilean Bibliometro
scheme lends 440,000 volumes
a year from its 20 locations on
the underground system in
Santiago. It has around 50,000
active users and 90,000 available
volumes. Although the majority
of the stock is in Spanish,
there are also books in English
at Irarrázaval-Macul, and in
Japanese at Quinta Normal.

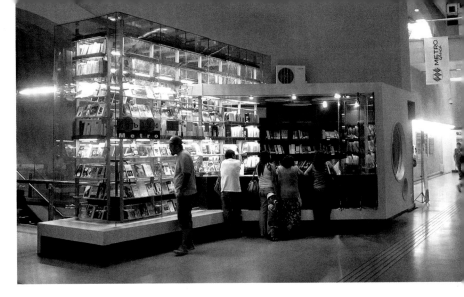

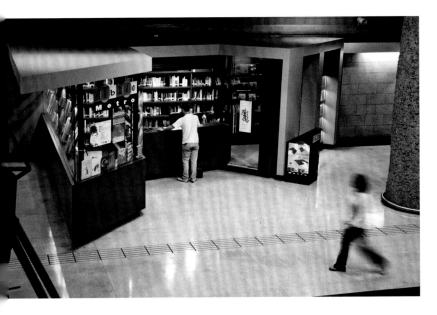

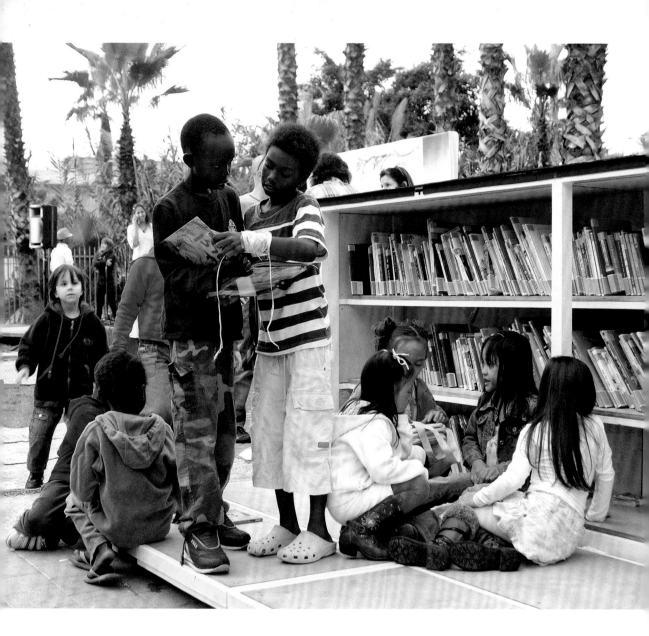

Sheltering in the stacks

The Garden Library was built in 2009 around a public bomb shelter in Levinsky Park near the Tel Aviv central bus station. ARTEAM, an interdisciplinary art NGO, and Mesila, a support project for immigrants, set up the library, which is now run by 100 volunteers. It supports members of foreign communities in Israel, refugees and migrant workers, although it is also popular with native-born residents. It offers a children's after-school programme and a range of cultural events and courses, as well as simply being somewhere to rest without facing questions from a guard.

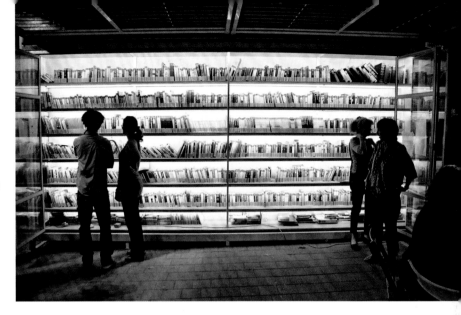

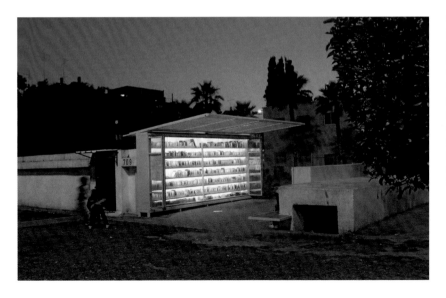

The library's two glass bookcases hold around 3,500 books in sixteen different languages, including Mandarin, Tigrigna, Amharic, Thai, Tagalog, Turkish, Romanian and Russian. The books are not catalogued by genre or author, but by readers' emotional responses to them: amusing, boring, bizarre, depressing, exciting, inspiring or sentimental.

Antropofagia
Existiu

Gostou do livro? Então leve para casa!

BIBLIOTÁXI

O projeto Bibliotáxi incentiva a leitura e a troca de conhecimento entre os passageiros da Easy Taxi.

Funciona assim: você leva qualquer livro para casa e, após lê-lo, o devolve em sua próxima corrida pela Easy Taxi. Ah, e você também pode ajudar a aumentar esta corrente, doando um livro para qualquer Easytaxista!

Fácil, não? Agora é só escolher e ler!

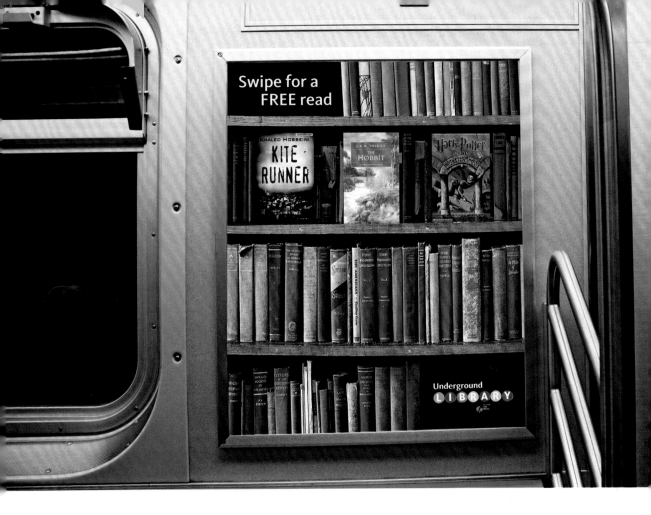

Bibliotaxi

Bibliotaxi was started by São Paulo taxi driver Antônio Miranda, who lent books to his regular passengers. With help from the NGO Instituto Mobilidade Verde, it has become a standard feature of the company Easy Taxi.

Underground Library

Designed by students from the Miami Ad School, this virtual library could allow New York City subway riders to read the first few pages of a book by swiping a smartphone against an onboard poster. They are then sent a map showing the nearest library that has a physical copy available.

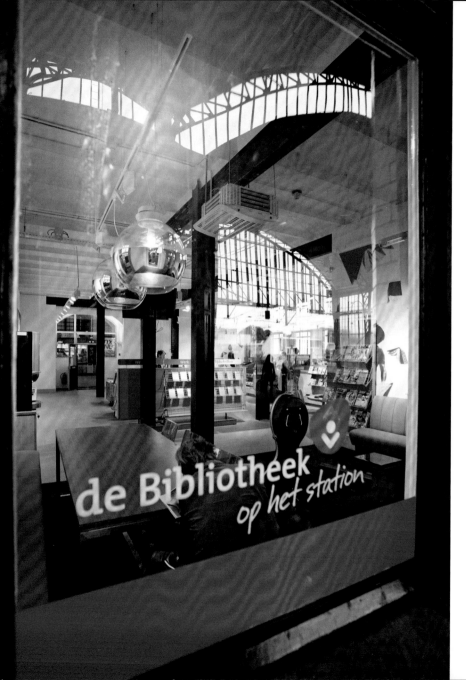

Library at the Station
The Haarlem train station library, aimed at commuters, is partly inspired by similar library projects on Dutch beaches. The goal of organizers ProBiblio is to extend the concept to ten stations across the national railway network.

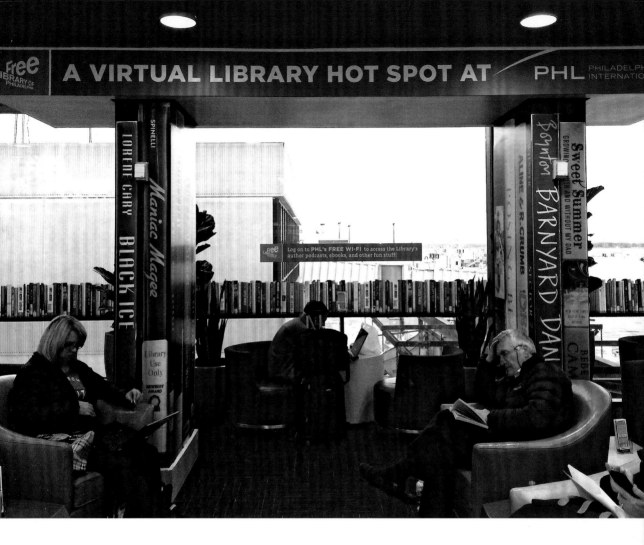

Passport to literacy

Jennifer Donsky, the Philadelphia Free Library's
public technology coordinator, describes the
library at the Philadelphia International Airport
as a 'passport to literacy, learning and inspiration',
whatever its readers' final destinations.

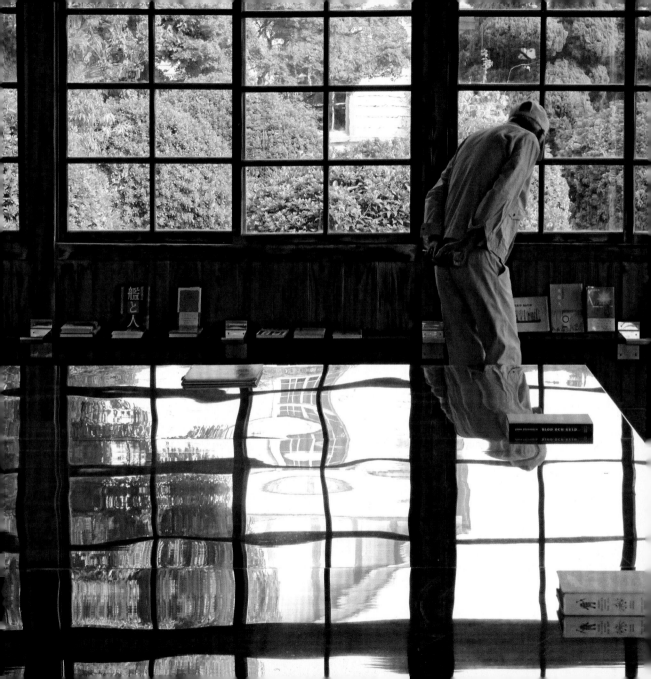

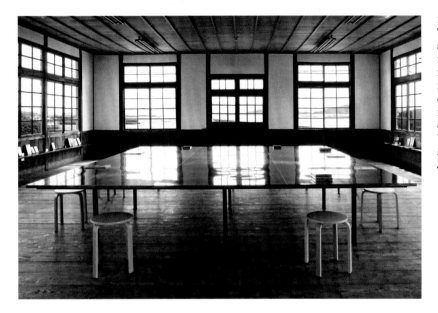

The library interior features a brass table with a gently rippled surface in the main reading area (left) and a rippled brass screen in front of one wall, creating wavy reflections that are reminiscent of water outside. Matching brass shelf labels (below) announce subject divisions in Japanese and English.

The Sea Library

The Sea Library, in a 1920s schoolhouse on Awashima Island in the Seto Inland Sea, Japan, was designed by Swedish architects ETAT Arkitekter for the 2013 Art Setouchi Triennale. The aim of the project was to re-create the spirit of international intellectual exchange that characterized the great seaport libraries of the past, in cities such as Alexandria and Venice, which attracted travellers, sailors, merchants and visiting scholars from all around the world.

Airport library takes off

The groundbreaking concept of
Amsterdam Airport Schiphol's
library has been followed by
half a dozen other airports around
the world, mainly in the US.
The Schiphol library stock focuses
on Dutch architecture, visual arts,
design, fashion and history. The
unstaffed library is open 24 hours
a day every day of the year. It
offers eleven seats at the large
central reading table and fourteen
comfortable lounging seats. Some
of the seating even incorporates
inbuilt iPads.

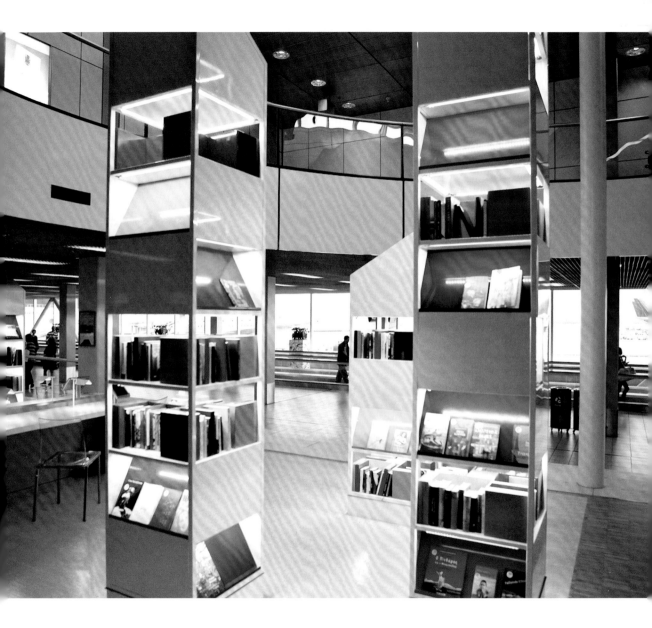

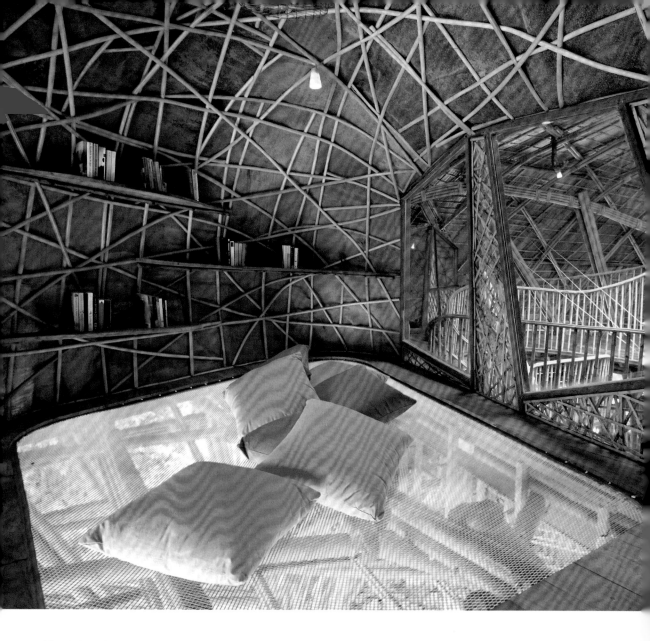

Library of best resort

Dutch firm 24H>architecture designed this library and entertainment complex for children at the Soneva Kiri resort in Koh Kood, Thailand. The library area boasts comfortable pillows, a cosy suspended pod, and a net for lounging. The complex also houses a cinema, art and music rooms, chill-balcony and slide.

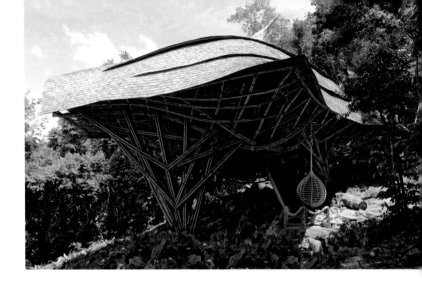

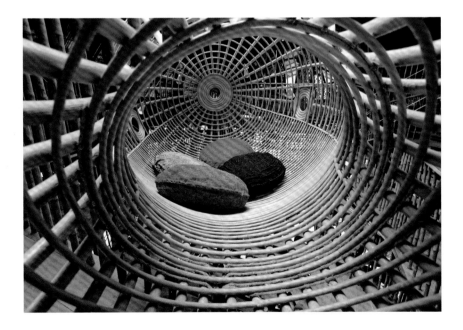

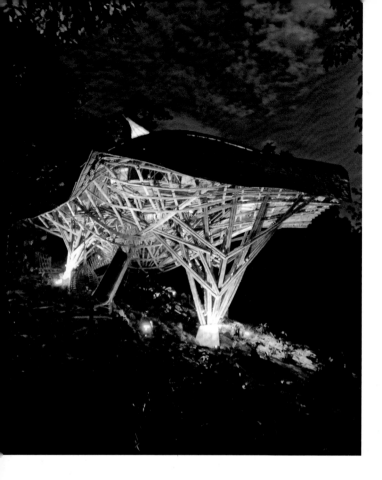

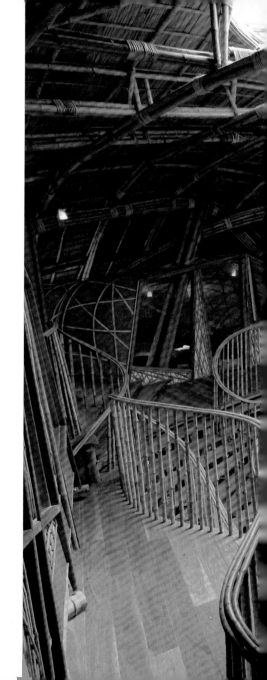

The bamboo dome is designed to
resemble a manta ray. Much of
the bamboo is sourced locally, as
is the river red gum wood used
in the interior.

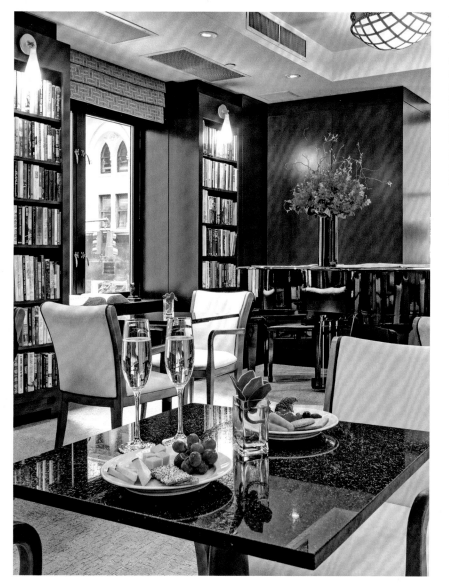

The Library Hotel

The Library Hotel in New York City is organized around an elaborate literary theme, with carefully selected collections of books in nearly every area of the building. Its main reading room, pictured here, is open 24 hours a day, and offers complimentary snacks and drinks along with several thousand books.

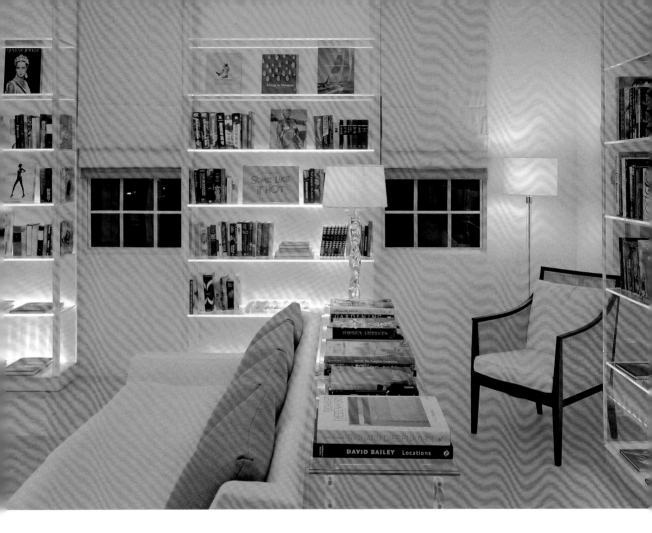

Ultimate book club

Fibre-optic lighting brings a nightclub
vibe to the library at the Carlisle Bay
resort in Antigua. The collection, curated
by the Ultimate Library company, features
travel journalists' favourite beach reads.

The Library resort

The Library resort on Koh Samui, Thailand, boasts a magnificent 1,300-volume library from which books can be bought as well as borrowed. Fibreglass statues of readers enjoying books adorn the hotel grounds.

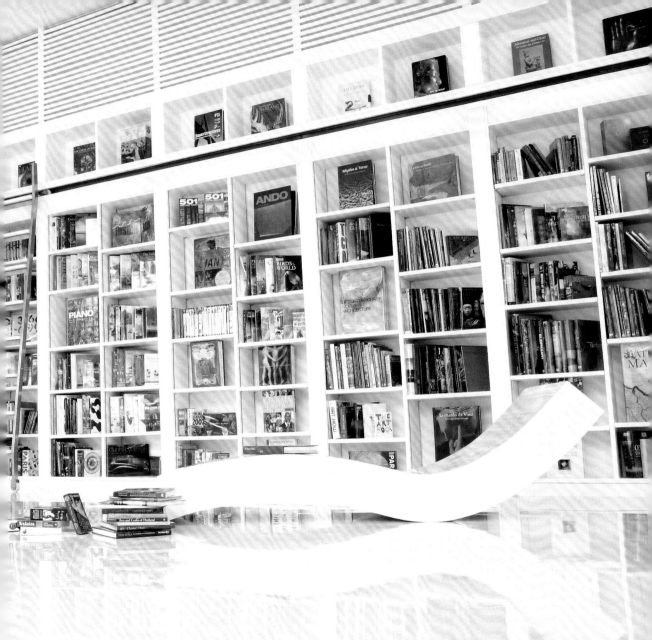

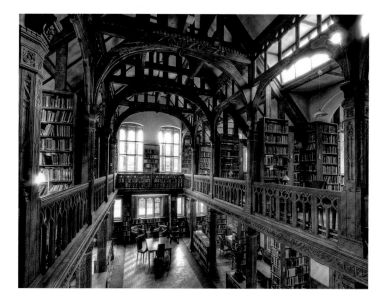

Gladstone's Library

The luxury 'residential library', hotel and conference centre occupies the former stately home of Victorian British Prime Minister William Gladstone in North Wales. During Gladstone's lifetime, his spectacular book collection was housed in a series of large iron temporary rooms known as the 'Tin Tabernacle' or 'Iron Library'. The imposing present library was built after Gladstone's death and funded by public donations in his memory; it opened in 1902.

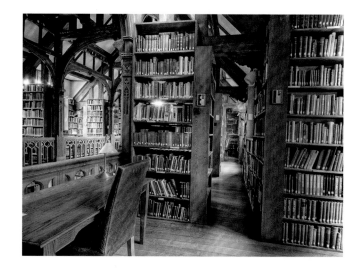

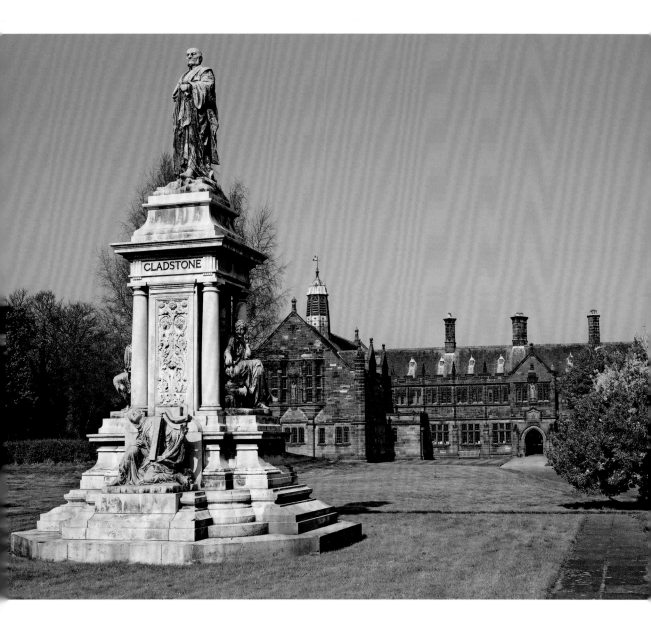

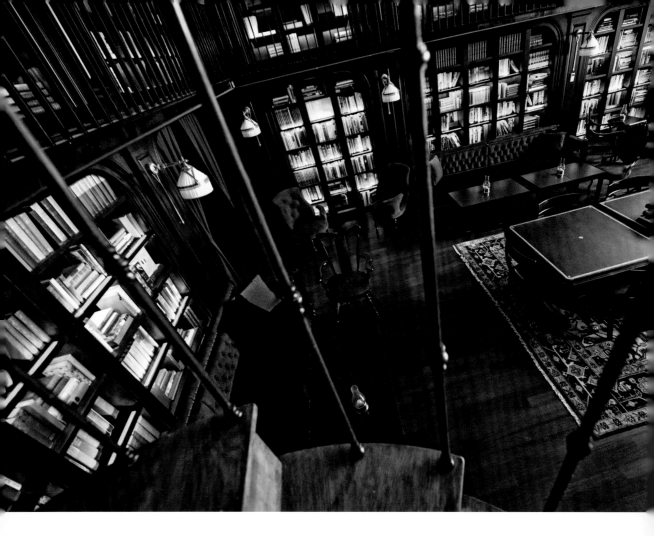

NoMad library

The hotel library is split over two levels and features a mezzanine catwalk with an antique French spiral staircase. If its eclectic collection of 3,500 books doesn't tempt, pastries are also served from 8 AM to noon and snacks from 5 PM to midnight.

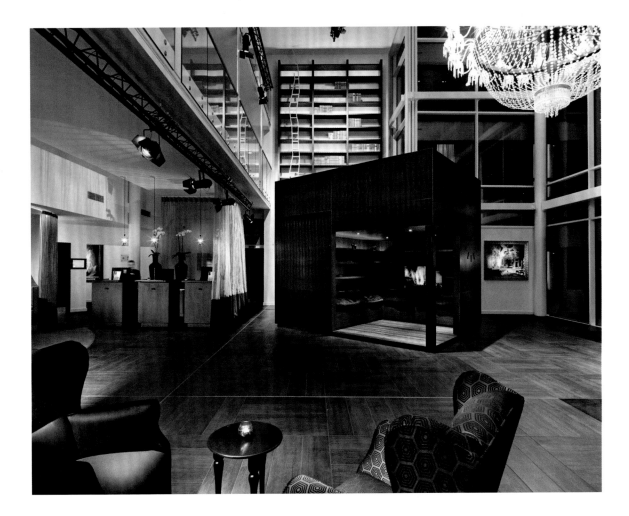

Book nook

In the lobby at the Radisson Blu Edwardian hotel in Guildford, England, a large wooden cube with images of a toasty fire on the television screen provides a cosy space for reading. The books themselves are on the floor-to-ceiling shelving behind the cube.

2.
Animal Libraries

Traditional libraries are expensive to build and are generally beyond the reach of impoverished and remote rural communities. Mobile libraries are the obvious solution, but motor vehicles can be expensive to run and require good and reliable roads. Libraries carried by animals, however, can travel over rough ground in areas with limited infrastructure, have low running costs and are extremely environmentally friendly. There are many examples around the world of well-loved animals helping to provide library services to children and adults in otherwise inaccessible places.

Horse-drawn bookmobiles were the earliest libraries to serve the vast, thinly populated rural areas of the US during the early 20th century. The first was set up in 1905 by Mary Titcomb of the Washington County Free Library in Maryland. A wagon carried boxes of books to the general store or post office in small towns throughout the county. The design of the library wagon was quite discreet until one farmer who saw it approach mistook it for a funeral hearse and turned it away, at which point it was painted red.

Several decades later, in 1935, the Pack Horse Library Project provided books and other reading matter to people living in rural areas of eastern Kentucky who had no public

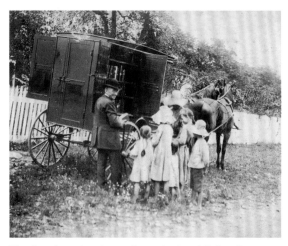

The first American horse-drawn bookmobile handing out the books to schoolchildren in Washington County, Maryland, *c.* 1905.

libraries nearby. The scheme was part of the Works Progress Administration (WPA), and specifically aimed at creating jobs for women during the Great Depression. The WPA paid for the librarians to maintain a headquarters, from which they rode horses or mules up to 130 km (80 miles) a week across rocky and muddy ground to deliver to some of the most remote areas of Appalachia. Sometimes the homes were so difficult to reach that the librarians were forced to dismount and continue on foot or by rowboat. Magazines, especially practical

titles such as *Women's Home Companion* and *Popular Mechanics* were far more popular among adult library customers than books, but children's books were always in greatest demand.

Biblioburro is a travelling library in Colombia that distributes books to communities in the country's Caribbean hinterlands from pouches carried on the backs of two donkeys, Alfa and Beto. Established by primary school teacher Luis Soriano, the original starting library of 70 books has now grown to more than 5,000 and the project

has become a family affair with his wife and children helping with the administration. Children's adventure stories are one of the most popular genres stocked by the Biblioburros, which also carry a range of fiction, encyclopaedias and medical textbooks. A copy of Paulo Coelho's novel *Brida* was famously stolen from the library by bandits: after they tied Luis up, they discovered he had no money with him, but still took the book. Luis, who also had his left leg amputated after an accident involving one of the biblioburros in 2012, says 'We work voluntarily with very few resources but with plenty of blood, sweat and tears, although we also work for the love of it.'

In Nkayi District, north-western Zimbabwe, the Donkey Drawn Libraries providing outreach services to remote communities have been hugely successful. It is estimated that the literacy rate in this area is now as high as 86%, largely as a result of the donkey libraries.

Donkeys have also been a key element of the mobile library service run by Ethiopia Reads since 2005, although they are now being phased out as part of a new programme that uses horses and motorcycles. In addition to providing books, the travelling librarians teach lessons in Amharic, English, maths and science to local children several times a week.

A Pack Horse Librarian during a visit to a remote mountain home in eastern Kentucky in the 1930s.

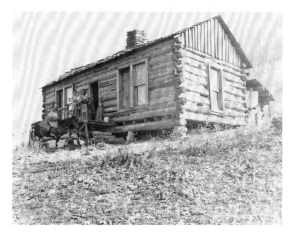

As Jennifer Martin from the organization explains, 'The librarian enters the village and calls the children in from the fields where they are working as shepherds and farmers, or out collecting water. They gather under the shade of a big tree for a lesson. Up to 200 children meet at a time.'

Remote mountain villages in Venezuela receive library books from mules via the Bibliomulas project initiated by the University of Momboy in 2010. Operating under the guidance of Professor Rosalía Ramírez, it now has two mules, Cenizo and Canela (a third, Golondrina, was stolen at the start of 2013), looked after by 'bibliomuleros' Nelson Salcedo and Ruben Vasquez. In addition to carrying books, Bibliomulas also brings laptops and wireless modems to the villages, many of which have limited mobile phone signal coverage, to help residents take advantage of what little signal there is.

Big Brother Mouse is a nonproft Laos-based charity that has been publishing books in the Lao language since 2006, as well as organizing teacher-training sessions and book parties in rural villages, and operating a bookshop in Vientiane. The project is particularly important since books in the Lao language have traditionally been hard to get hold of. Big Brother Mouse has published more than 300 Lao books on subjects ranging from women's health to *The Diary of Anne Frank*. The staff also run reading tests in rural schools, measuring improvement over the course of a year. Many villages are not on a road network and can only be reached by boat or on foot. Now, thanks to Big Brother Mouse, some communities in Sainyabuli Province are visited by a mobile library carried by an elephant called Boom-Boom ('boom' means 'book' in Lao). According to the organizers, children have always been excited when the Big Brother Mouse team arrives in their village, but are even more excited now that they arrive with an elephant. Traditional Lao fairy tales are the most popular titles, followed by books about sea life, insects and dinosaurs. Older readers are keen on Lao cookbooks, which are otherwise not widely available.

Mongolian author Jambyn Dashdondog has not only written dozens of children's books and poetry collections, but for the last 20 years he has personally ridden a camel – as well as horses, cows and reindeer – to bring books to younger readers all around the country as part of his long-running Mongolian Children's Mobile Library project, which began working in partnership with the charity Go Help in 2011. There are also several camel-based 'bookmobiles' in Kenya, the first set up in

1985 by the Kenya National Library Service. These camel libraries make regular visits to villages, especially in the drought-stricken eastern part of the country.

In many of the most remote areas around the world, the mobile library stays true to its horse-powered predecessors. Whether by horse, donkey, mule, elephant or camel, these tried and tested traditional methods of haulage are still preferred by librarians even after a century of motorized power.

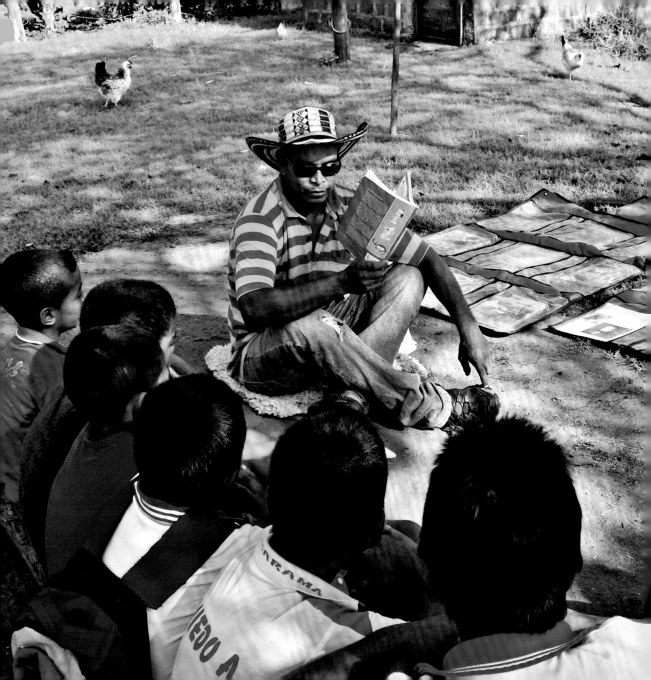

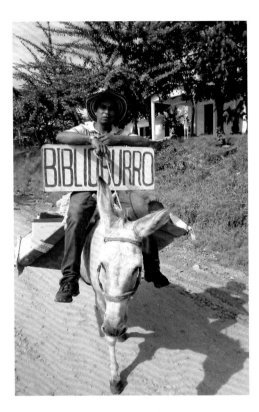

Biblioburro

Primary school teacher Luis Soriano (pictured above and left) founded and runs the Biblioburro travelling library project as a labour of love, braving bandits and broken bones to bring books to remote Colombian villages.

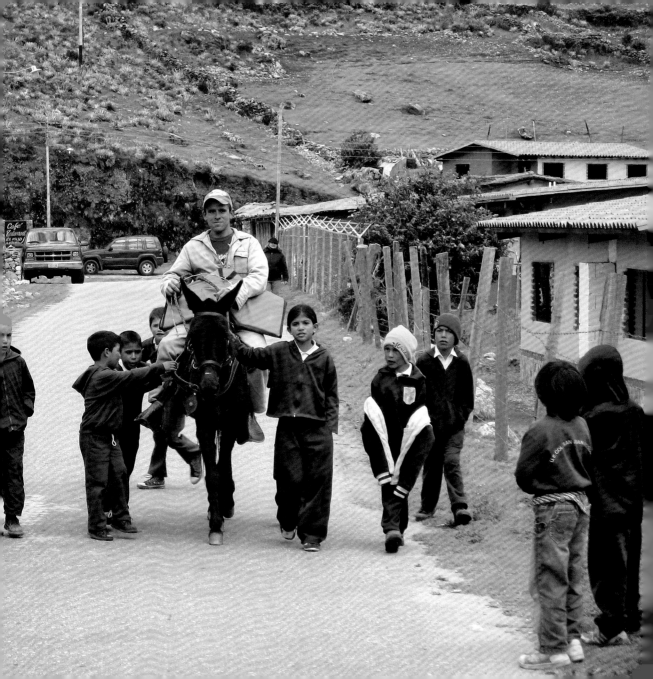

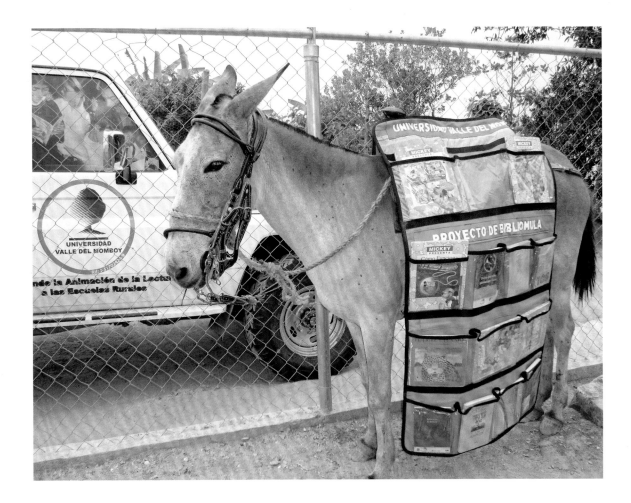

Bibliomulas

Supported by the University of Momboy, the 'Bibliomuleros' make weekly visits to schools in rural communities high in the Venezuelan Andes. The mules sometimes carry donated clothes and even wireless modems as well as reading material.

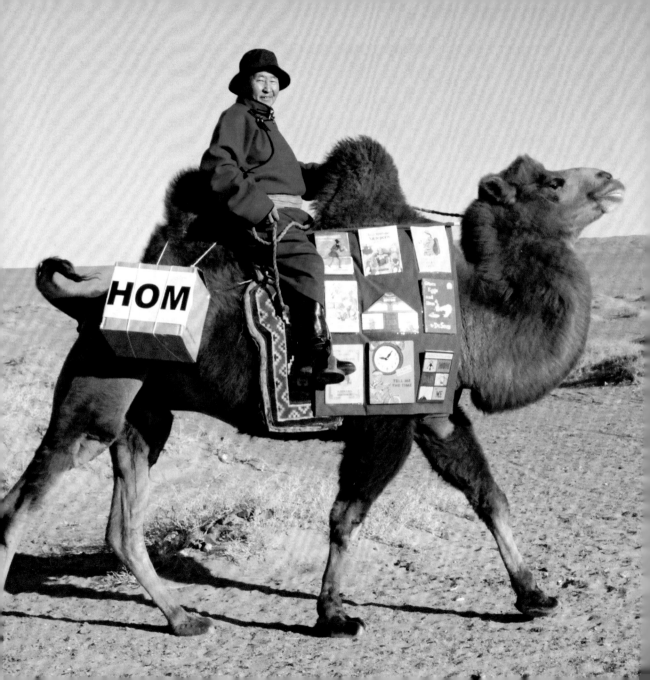

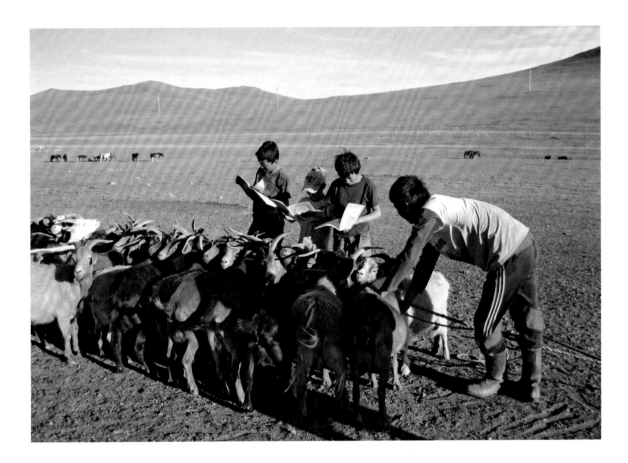

Camel

The Mongolian Children's Mobile Library carries books to nomadic herding communities and remote areas of the Gobi desert. Founder Jambyn Dashdondog has written more than 70 children's books. The project also advises parents in encouraging a love of reading in the children.

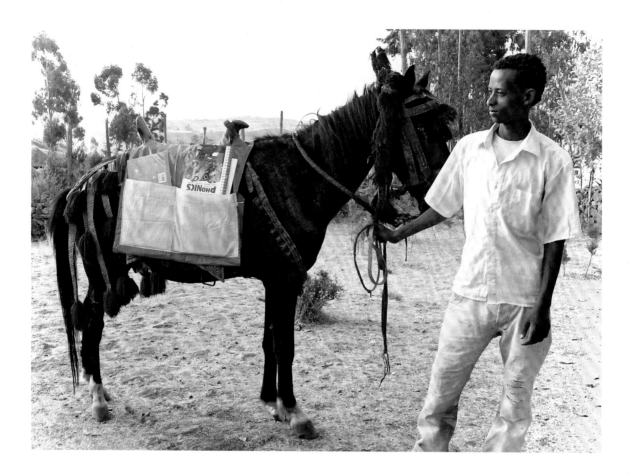

Ethiopia Reads
The Ethiopia Reads mobile libraries are brought by donkey, horse and motorcycle to children who would otherwise have no experience of books. Librarians read stories to the children and suggest titles for them to borrow.

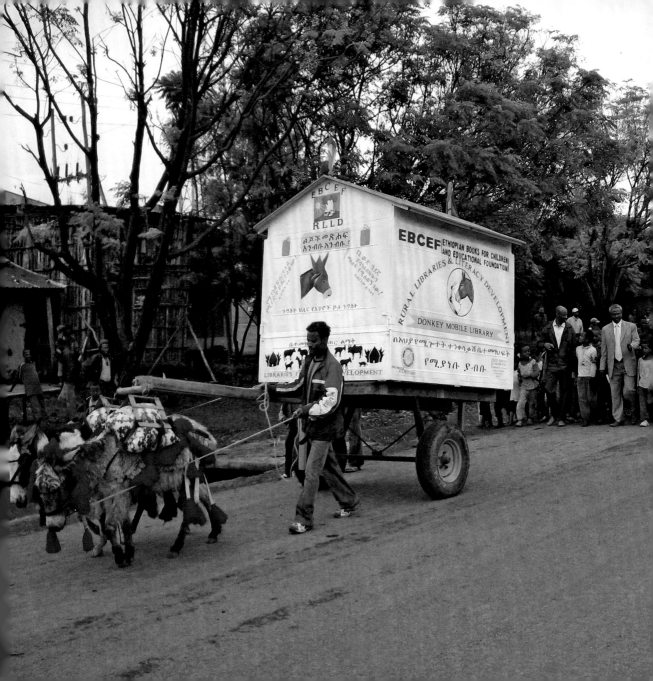

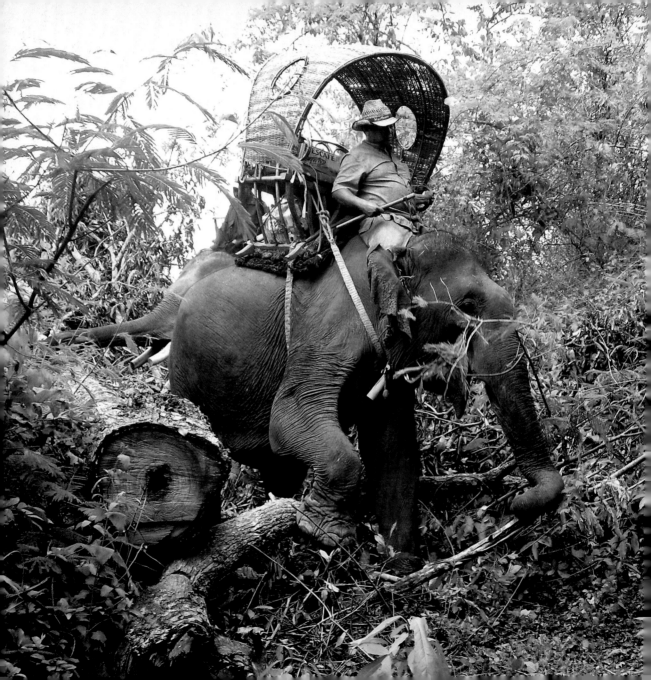

Elephantine library

Boom-Boom the elephant
is an important figure in the
Big Brother Mouse publishing
and library services project in
Sainyabuli Province, Laos.
There is no other system for
getting books into these rural
villages, some of which are two
days' travel from the nearest
road or navigable river.

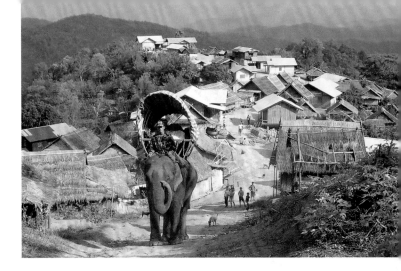

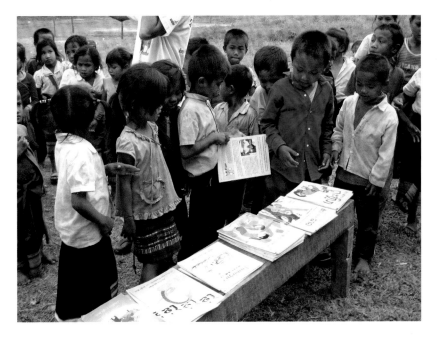

LEFT
Each child can borrow one
book from the elephant
library and more are left at
the school so the children
can swap their selections
for new ones later.

3.
Tiny
Libraries

iny libraries in converted phone booths, purpose-built kiosks, experimental art installations, quirky handmade boxes – and even one refrigerator – are springing up on street corners around the world at a rapid rate. These miniature lending libraries lead the communal book revolution, bringing reading material to the masses at a level that far exceeds their size.

In an age when online reading on smartphones and tablets seems to threaten traditional bricks-and-mortar libraries, the introduction of mobile phones has inadvertently given rise to a whole new type of library building: the telephone box. By 2002 British Telecom had 92,000 phone boxes in Britain, but around half of these have since been removed in response to the bulldozing popularity of mobile phones. Rather than simply rip out the rest, the company came up with its Adopt a Kiosk programme in 2009. Communities were offered the chance to buy one of the iconic red telephone boxes for £1, and encouraged to turn them into spaces that local residents would actually use. The scheme has been a great success, and in more than 1,500 of these pieces of microarchitecture (originally designed by Giles Gilbert Scott and launched in 1935 for King George V's Silver Jubilee) grocery stores, wildlife

information centres, tea rooms, art galleries and defibrillator points have been set up, as have dozens of new community libraries. Their lending rules vary as much as their official titles – book exchange, book swap, book box – but most operate on an honesty basis. Local users take and return books from shelves added inside the telephone box, donating additional books at will, and there are no fines for late return.

An ocean away, in the US, the Book Booth is an official branch of the Clinton Community Library in Clinton Corners, New York State. The telephone box is technically the property of David and Jeanie Bean, who had it shipped over from the UK in 1990 to stand outside their British Tea Room in town. Now, the Beans have generously loaned their phone box to the Friends of the Clinton Community Library. 'I believe we are the only phone box library equipped with a solar light,' says project founder Claudia Cooley, who helped to set it up after reading about the first British phone-box library. 'I adamantly said no locks, no specific hours: our little library will be open 24 hours a day, 365 days a year, and I'm going to install a motion-sensor solar light so when someone has late-night book munchies, they'll open the door and voilà, the light will pop on. New books are added every day or two, and a couple

taken away. Sometimes the shelves are messy, sometimes people leave little notes. I find the whole package as beautiful as art.' Cooley also says that the Book Booth builds community spirit and helps local businesses by attracting visitors to the area.

It isn't only in rural areas that unused phone boxes are being transformed into libraries. Architectural designer John Locke has repurposed four phone booths in New York City as pop-up libraries, the latest at Amsterdam Avenue and West 87th Street. His first attempt ended earlier than expected when somebody walked off with the entire stock within a few hours, so for the second, Locke added a visible logo to the spine of each book to discourage theft. His ultimate aim is to preserve the special social space that phone booths provide in cities. 'They're dead technology, perched on the edge of obsolescence, harking back to a lost shared public space we might no longer have any use for. But they can also be a place of opportunity, something to reprogram and somewhere to come together and share a good book with your neighbours.' Books for his kiosks, part of his Department of Urban Betterment project, are donated by local residents. Locke designs and makes the plywood shelving that he then hangs from the booths, which are still fully functional for calls.

Another urban telephone-booth project has been set up in Prague. KnihoBudka, the brainchild of friends and local residents Monika Serbusová and Pavel Železný, and now supported by Czech telecommunications operator Telefónica in a scheme similar to British Telecom's, transforms disused telephone booths into small libraries at a range of urban locations, including hospitals, shopping malls and railway stations.

These telephone-box libraries have inspired a wide variety of other tiny outdoor libraries on street corners around the world, including Bücherwald ('Book Forest') made by BauFachFrau in Berlin from entire tree trunks, the eight telephone-box-sized Swapping Bookshelves in Greece designed by Eirini-Aimilia Ioannidou and Eleftherios Ambatzis, the small sheltered Paraderos Para Libros Para Parques libraries with integral seating in Colombia and the self-explanatory De Wilde Boekenkast ('The Wild Bookcase') in the Netherlands. Even a disused commercial refrigerator has been repurposed as an urban mini-library, as part of the Gap Filler project in New Zealand following the Canterbury earthquake. Elsewhere, artists such as Didier Muller and Marta Wengorovius are making

outdoor art installations that also function as tiny libraries.

Perhaps the most successful tiny library project of the 21st century has been the Little Free Library (motto: 'Take a book, return a book'). These handmade weatherproof book cabinets, which often look rather like oversized bird boxes, are placed in front gardens, bus stops and parks, but also in coffee shops and near restaurants. Anyone can remove a volume and deposit another to share. The first library box, built by Todd Bol of Hudson, Wisconsin, in 2009, was a model of a one-room schoolhouse designed as a tribute to his mother, a former schoolteacher who loved reading. He erected it on a post in his front yard and then teamed up with social enterprise expert Rick Brooks. The project has since seized the public imagination: it is now estimated that there are more than 12,000 Little Free Libraries around the world, most in the US and Canada, but also in countries including Ghana, Pakistan, India and the Netherlands.

The goals of the Little Free Library enterprise, now a nonprofit organization, are not only to promote literacy and a love of reading among both children and adults, but also to build a sense of community by encouraging neighbours to meet up and chat while browsing new arrivals. Local

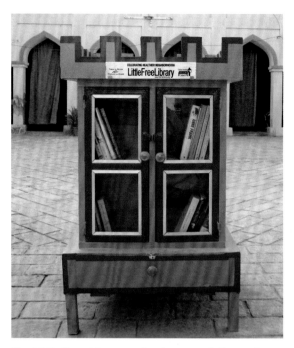

The Little Free Library project has spread all over the world. This kiosk in the Lakki Marwat region of Pakistan was built to resemble the architecture of local forts.

small business owners report that Little Free Libraries help them attract customers and estate agents say that they have even influenced potential homebuyers to decide to settle in the neighbourhood. 'If this were just about providing free books on a shelf, the whole idea might disappear after a few months,' say the organizers. 'Little Free Libraries have a unique, personal touch and

there is an understanding that real people are sharing their favourite books with their community. These aren't just any old books, this is a carefully curated collection and the Library itself is a piece of neighbourhood art!'

The architectural element of these libraries inspired an intriguing project in New York City in 2013 involving the Architectural League of New York and PEN World Voices Festival. Architects were paired with Lower Manhattan community organizations to design small book 'shelters' for their various neighbourhoods. In keeping with the ethos of the Little Free Library movement, the participants were asked to provide open-source design guidelines and installation instructions, permitting others to replicate these libraries in new settings. Among those who took part was Seung Teak Lee from interdisciplinary architectural practice stpmj, whose 'Mirror' library, built with Mi Jung and Andrew Ma in the Bowery neighbourhood, was designed to split into two pieces for easy portability and assembly, allowing it to be mounted on light poles, street signs or trees. Another eye-catching design came from the firm Stereotank, run by architects Marcelo Ertorteguy and Sara Valente. Unlike other Little Free Libraries, this design was partly 'inhabitable': the structure was built out of an upside-down plastic tank and a wooden frame with perforations that allowed visitors to peek inside before ducking underneath to visit the book collection.

A particularly ambitious – even 'monumental' – tiny library is the timber-frame Story Tower built in 2013 by design students of Riga Technical University in Latvia to provide the town of Cēsis with alternative facilities for reading and book-borrowing while the local library was closed for renovation. More than 2,500 shingles made from recycled Tetra Paks cover the roof, and bookshelves line its underside, forming a sheltered open-air reading room and book exchange inside the tall, tent-like structure.

Livre exchange

Didier Muller's *Librairie
Urbaine* is an installation of
small suspended cabins. Visitors
are encouraged to browse the
hanging containers, take any
book that intrigues them and
donate one to replace it.

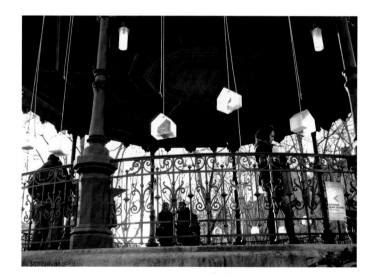

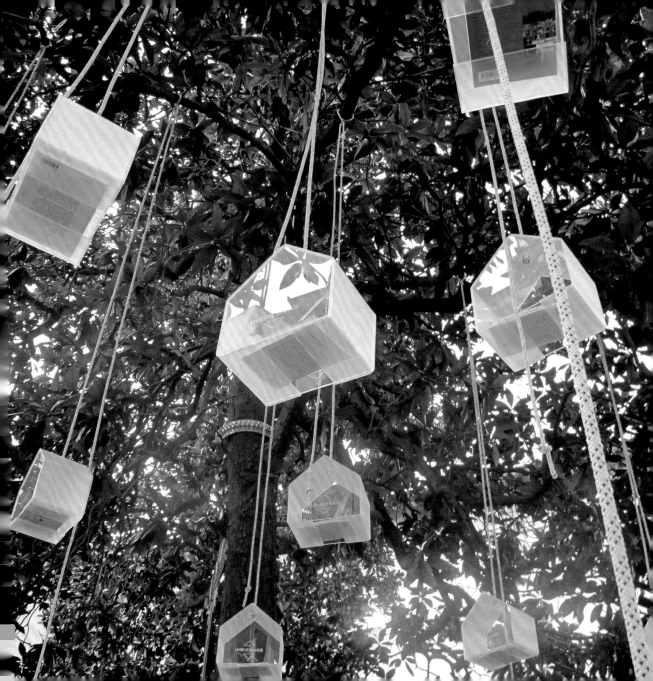

Calling for books

Longstock Parish Council's telephone-box library in an idyllic location in Hampshire, England, is one of many former British Telecom phone boxes that have been repurposed for community use with the company's blessing.

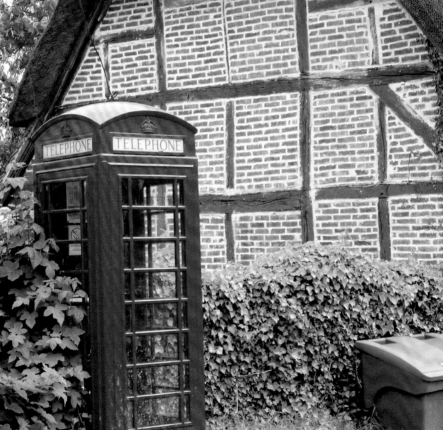

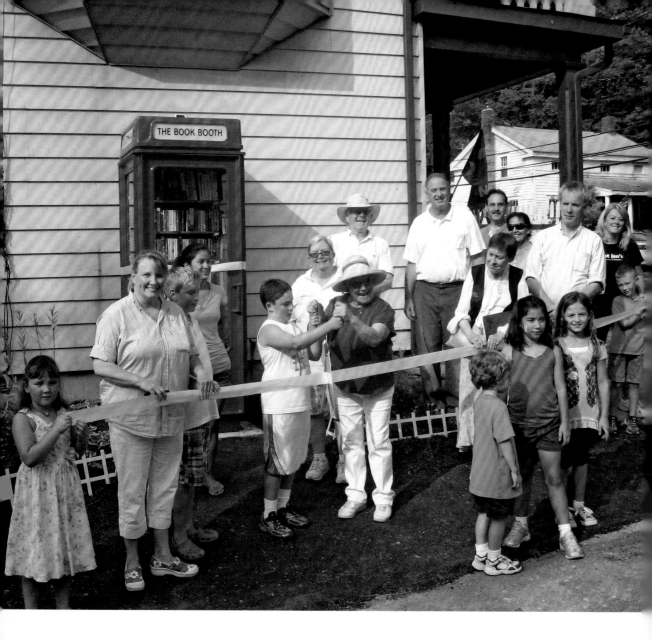

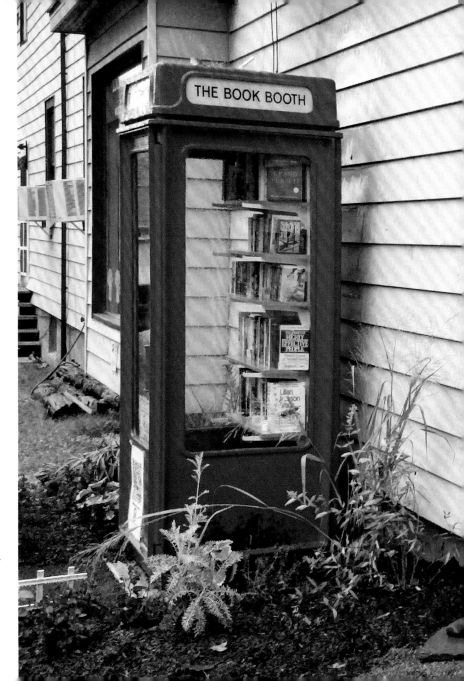

Transatlantic book booth

The Book Booth in Clinton Corners, New York State, is one of just over 50 surviving examples of the British K8 model designed by Bruce Martin. Now a solar-powered 24-hour community library, it stands outside the all-American small town's British Tea Room.

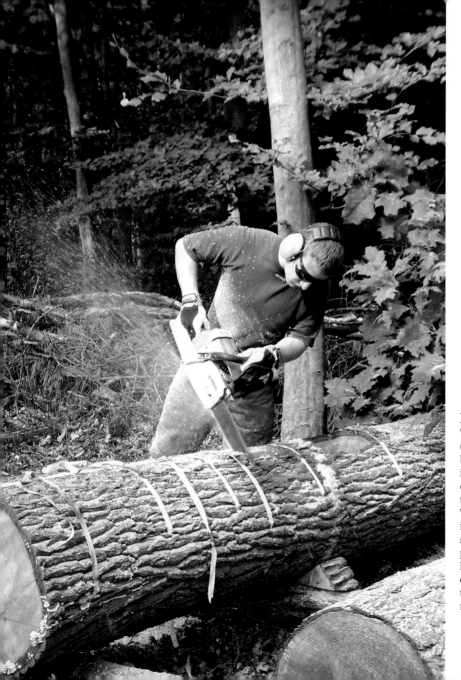

Forest of books

The Bücherwald miniature library (on a street in Berlin, opposite) is by design firm BauFachFrau. It is made from several tree trunks, cut at varying heights and bolted together, with the bark left intact. The rectangular box shapes cut into each trunk (left) provide space for around 100 books, protected from bad weather by heavy plastic flaps. Visitors are encouraged to withdraw anything that takes their fancy and also to make their own donations.

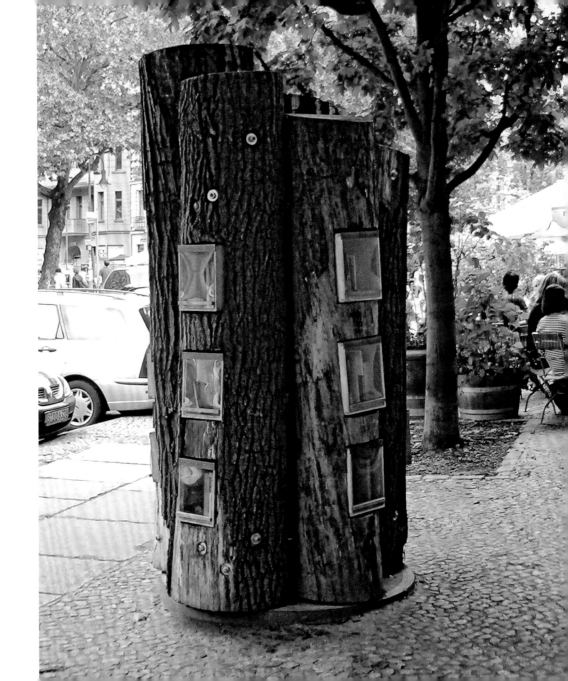

Park and read

The Paradero Para Libros Para Parques initiative has introduced more than 100 mini libraries in Colombia, approximately half of them in Bogotà. The project was set up in 1999 by nonprofit organization Fundalectura as part of a wider plan to promote literacy in the country. Each library stand has space for around 350 books and is manned by volunteers.

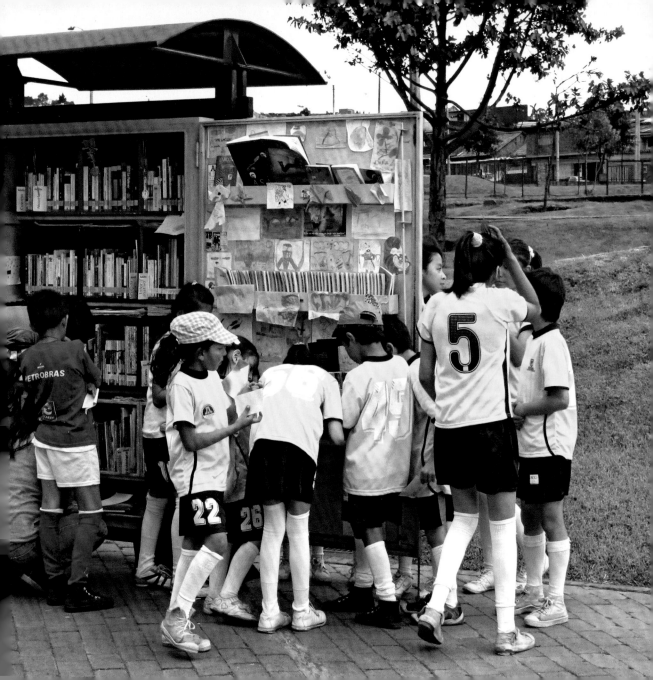

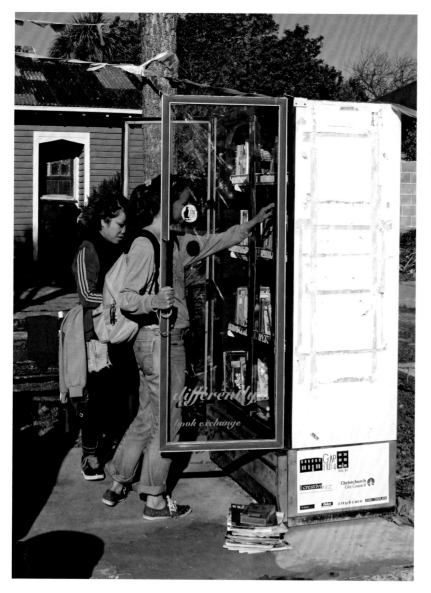

Gap Filler

The Think Differently Book Exchange was part of the Gap Filler urban regeneration initiative established in the aftermath of the 2010 Canterbury earthquake in New Zealand to repopulate temporarily vacant sites with creative projects, one of which was this glass-fronted book-exchange fridge.

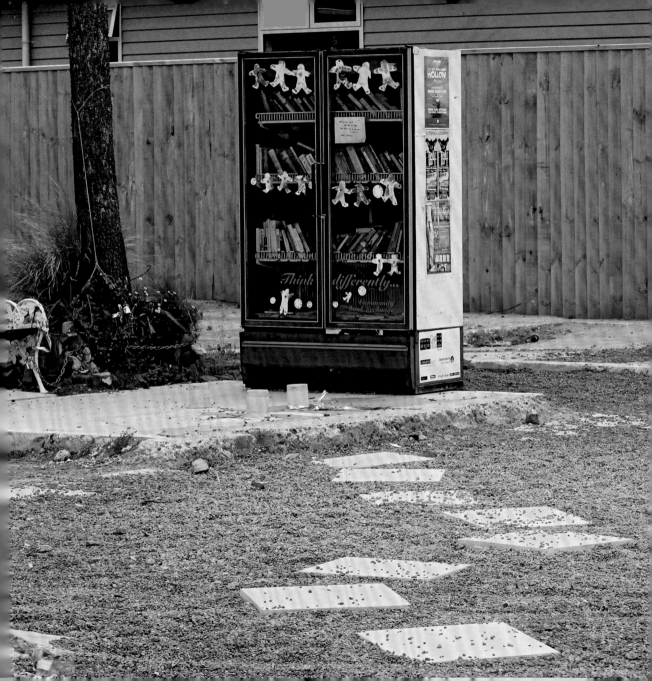

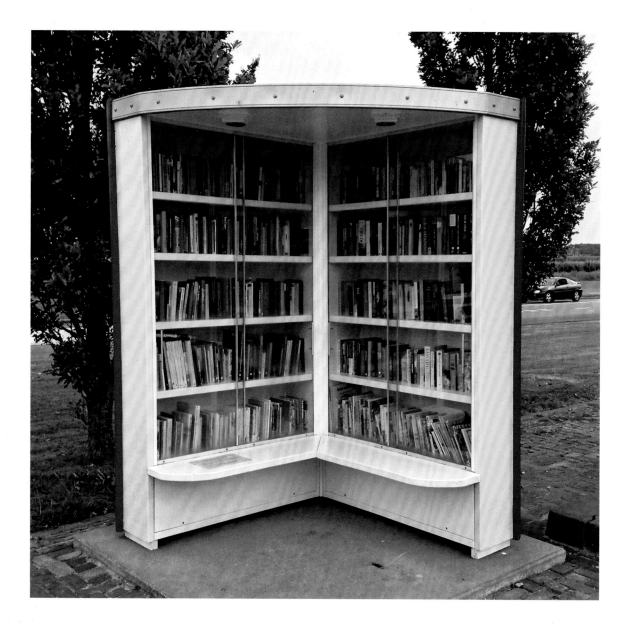

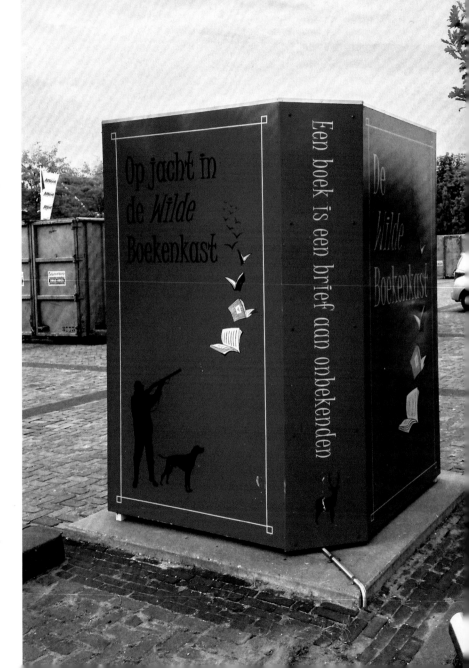

Wild bookcase

De Wilde Boekenkast ('The Wild Bookcase') is a free swapping library located in a public green space in Tollebeek, the Netherlands. It was officially opened by King Willem-Alexander and his wife Queen Máxima in 2013.

o The library is open 24/7.

USER GUIDE

When you bring a book…

o You don't need to take
 another.
o Find the «swap-it» stickers on
 one of the shelves and put it
 on your book's spine. From now
 on, it will travel with its ID.

What's best of course
is to give and take!
Don't wait! It's your turn
to make our library yours…

When you take a book…

o You don't need to bring another
o You don't need to bring it back
o Make sure the «swap-it» sticker
 is on. If not, put one on
 by yourself before taking it!

Swapping bookshelves

There are eight 'swapping
bookshelves' in Greece, each
around 2 m (6½ ft) tall. Architects
Eirini-Aimilia Ioannidou and
Eleftherios Ambatzis say
that their goal is 'to promote
interaction between citizens and
re-establish their relationship
with books and public space'.

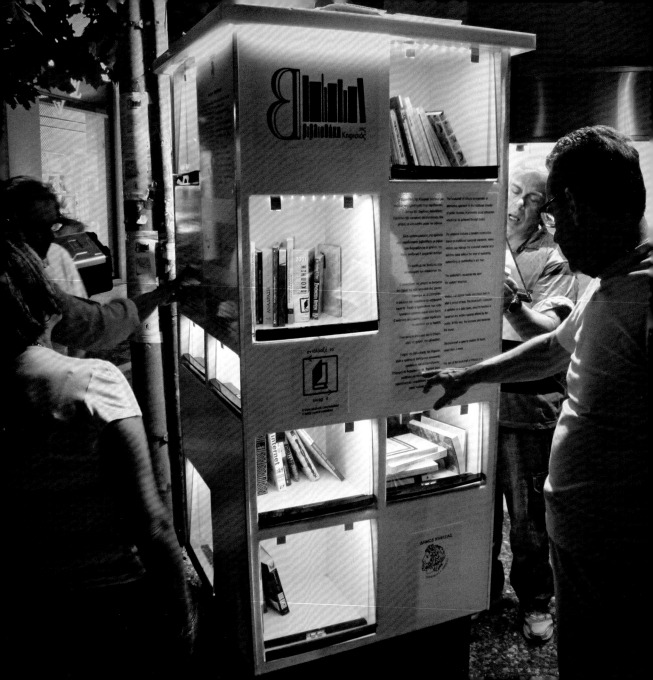

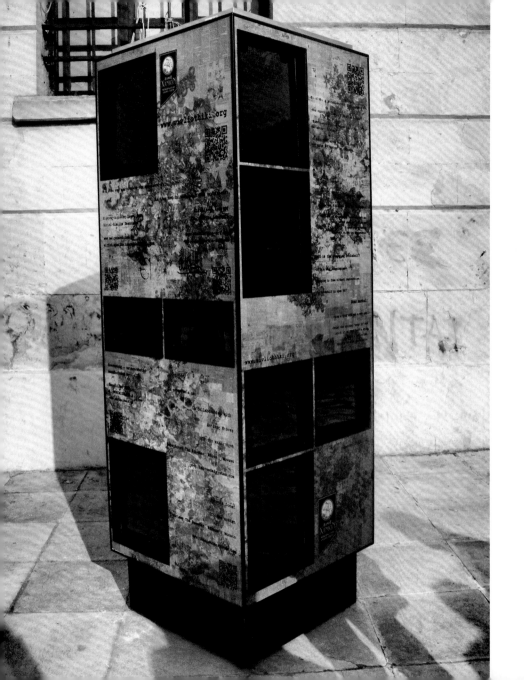

The first swapping bookshelf (right) was set up in 2012 in Kifissia, a suburb of Athens. Others have been set up elsewhere in Athens (below) and in Crete (opposite). Apart from books, some swapping bookshelves also offer games, puppets and puzzles.

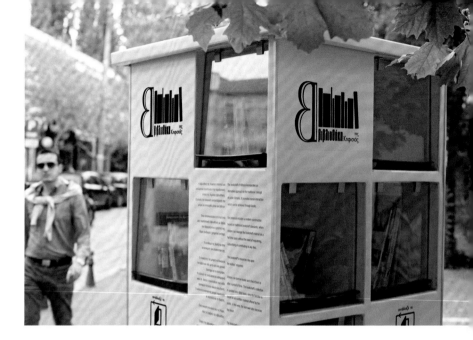

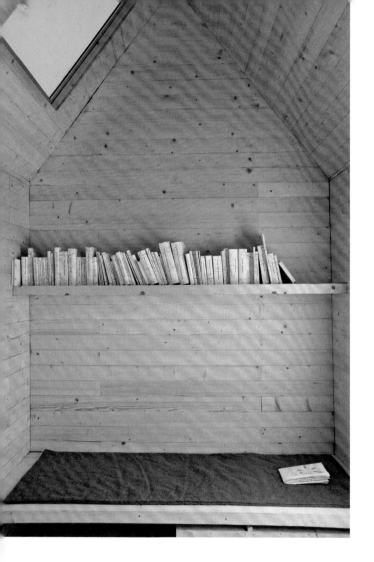

One, Two, Many

Portuguese artist Marta Wengorovius's peripatetic *One, Two, Many* project, designed with architect Francisco Aires Mateus, features a tiny shed-like library intended to be used by only one person at a time. It stocks 60 books and Wengorovius's goal is to move it to a different location every year.

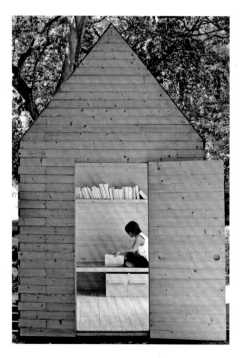

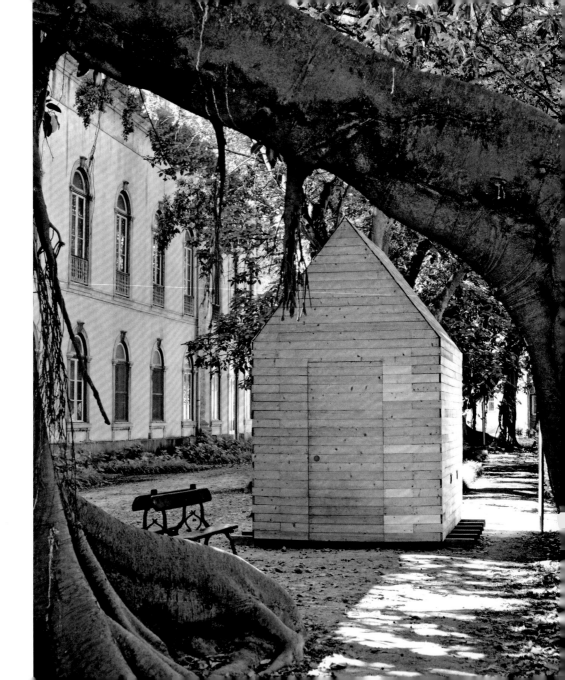

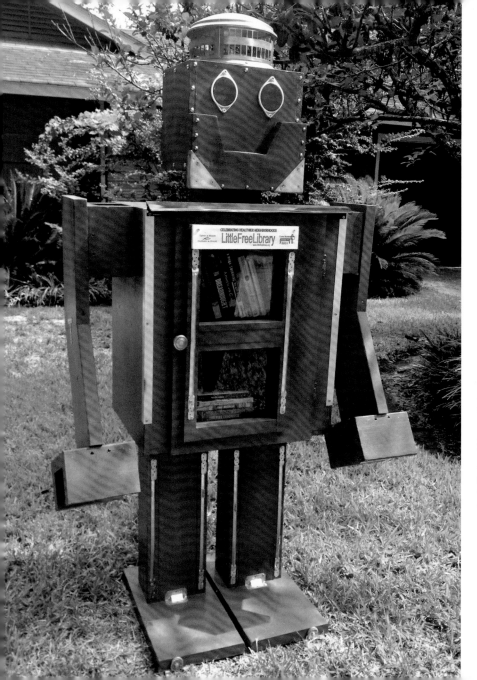

Libraries with a human touch

The more than 12,000 handmade Little Free Libraries around the world range from simple 'bird boxes' to imaginative themed constructions, such as this friendly robot in Houston, Texas (left), and a patriotic Ghanaian box (opposite).

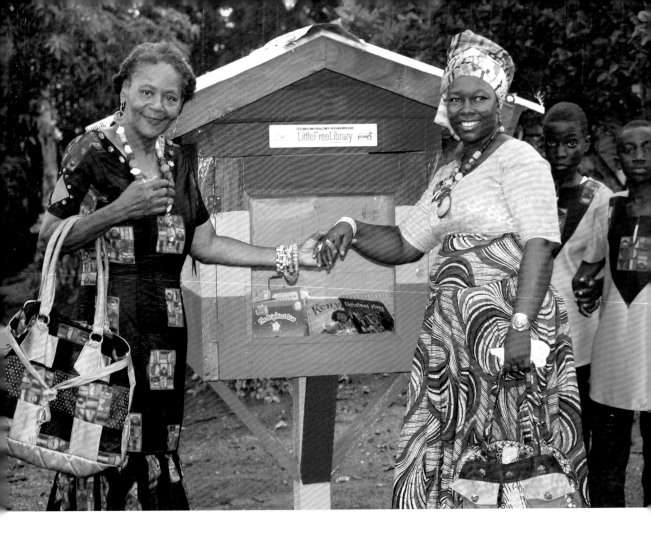

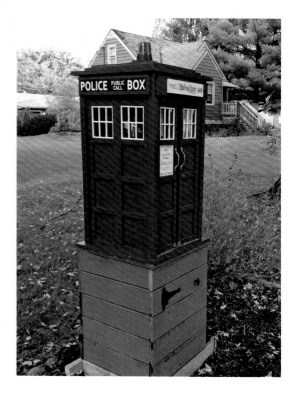

While some telephone boxes
have been turned into libraries,
this Little Free Library in Texas
takes the opposite approach.

Like Dr Who's Tardis, this
Little Free Library in Illinois
holds far more on the inside
than appears from the outside.

OPPOSITE
Although most Little Free
Libraries are installed in front
gardens, others are placed
in public spaces, such as this
example in a park in Iowa.

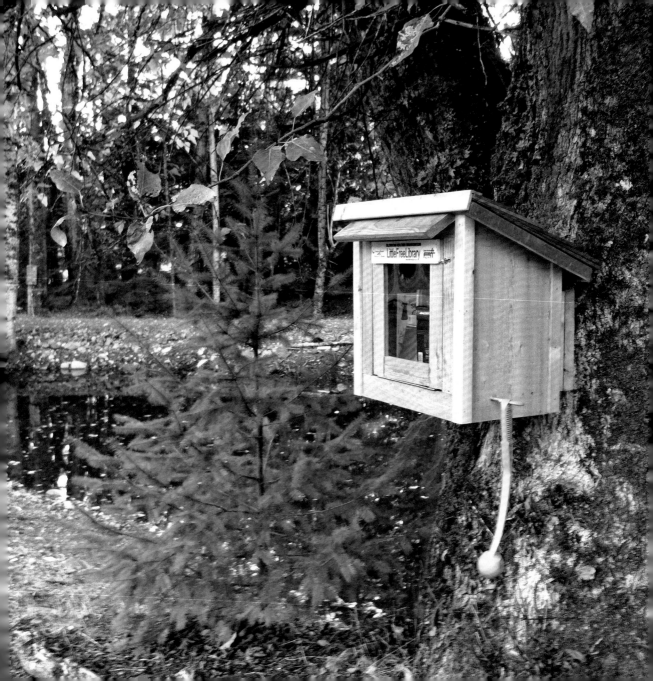

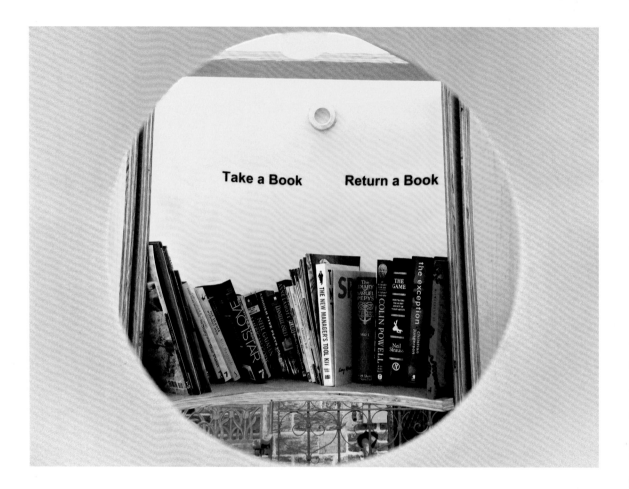

Take a Book **Return a Book**

Head full of books

An eye-catching Little Free Library
designed by Stereotank and erected
outside St Patrick's Old Cathedral School
in New York City's Nolita neighbourhood
also allows users to play peek-a-boo with
each other or shelter from the rain.

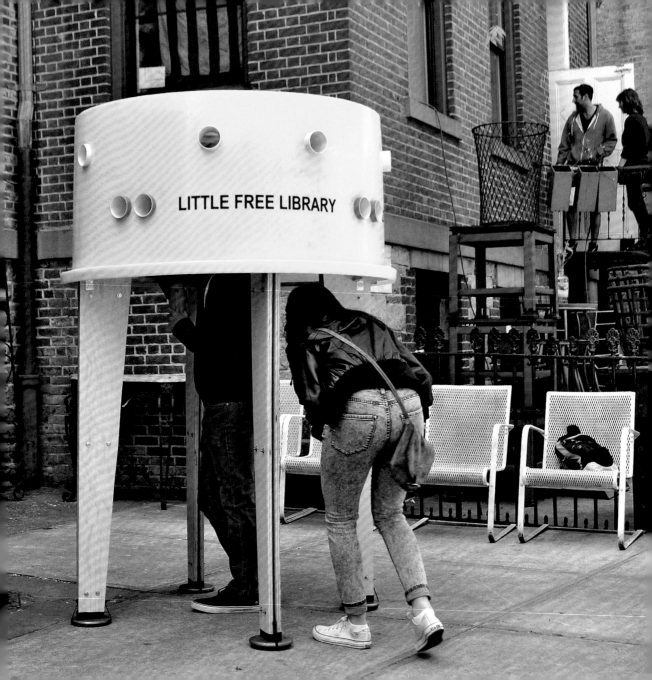

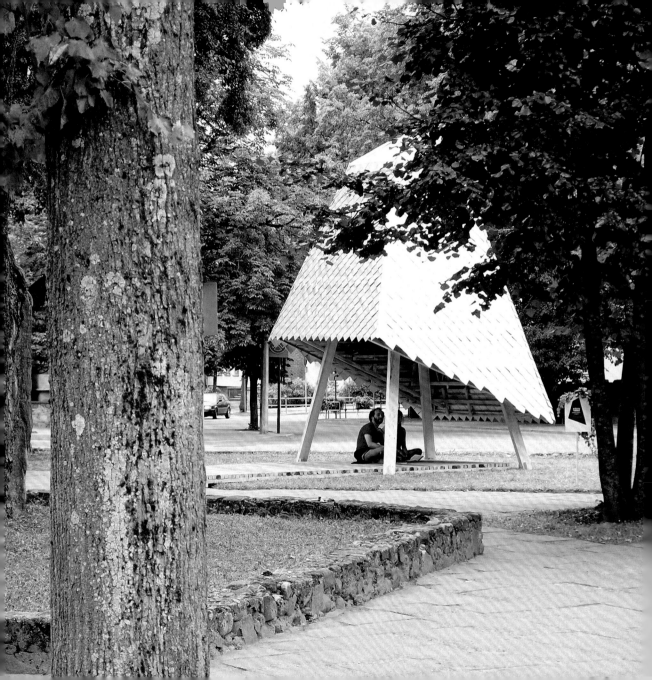

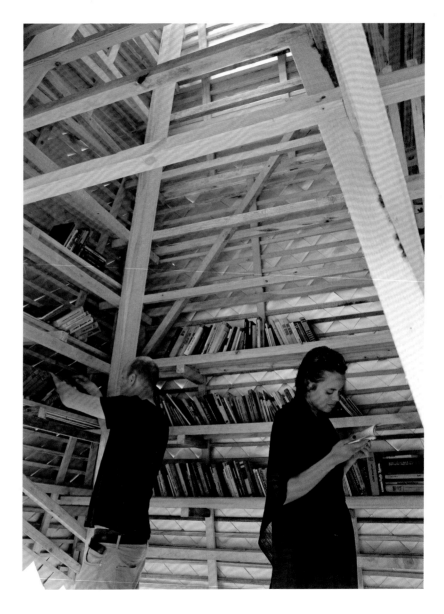

Story Tower

The Story Tower was built
by students at Riga Technical
University in Latvia as a
temporary open-air reading
room and book exchange shelf
for the town of Cēsis, whose
local library was closed for
renovation. The 5 m (16 ft)
wooden structure has a roof
made from folded Tetra Pak
containers.

THERE ARE 13659 PAYPHONES ON NYC SIDEWALKS

EVEN THOUGH THERE ARE OVER 17 MILLION CELL PHONES

IS THE PAY PHONE AN ANACHRONISM OR AN OPPORTUNITY...

Urban Betterment booth

'I'm interested in pay phones because they are both anachronistic and quotidian,' says artist John Locke of the motivations behind his 'Department of Urban Betterment' project, which demonstrates how New York City phone booths can be repurposed as tiny libraries. Locke installs the bookshelves in functioning phone booths in spots where pedestrians mingle on their way to and from home, shopping or leisure activities.

Through the looking glass

The Mirror Library was moved
around several different locations
in New York City, including Union
Square, street signage in the Wall
Street area and a tree in Central Park.

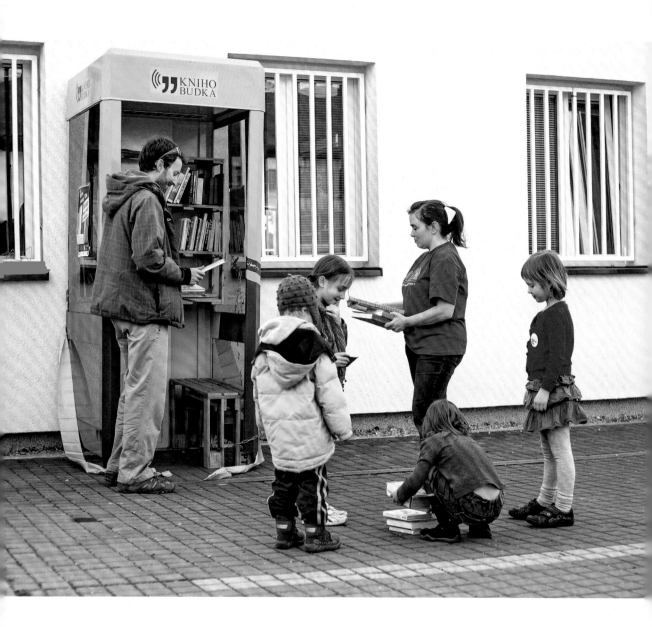

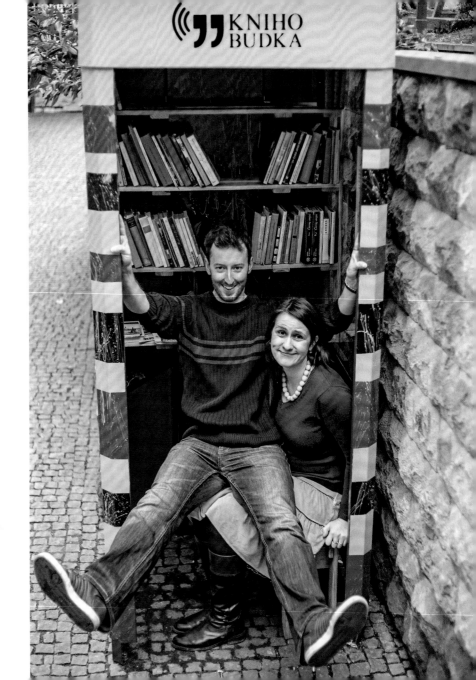

Czech-out booths

KnihoBudka ('BookBooths')
are converted Telefónica
booths in multiple locations
around Prague. The exterior
of each booth is decorated
differently; the first designs
were solicited from Facebook
users. The booths incorporate
benches, modelled by the
project's founders Monika
Serbusová and Pavel Železný
(right), allowing visitors to
sit and read as well as to
borrow books.

4.
Big
Libraries

While most of the libraries in this book are on a reasonably compact scale, larger bricks-and-mortar libraries are evolving in unexpected ways as well. University libraries, museum collections and public libraries are no longer invariably staid, columned Grecian edifices, or monolithic, functional box-like buildings. Their architecture is increasingly imaginative, incorporating unexpected features and multiple new functions.

At the most basic level, many of these innovative big libraries simply do not look at all like libraries. Take, for example, the library in a former railway station in Luckenwalde, Germany. The disused and increasingly dilapidated building for railway passengers has been wholly renovated to house the public city library. It now features a tilted rectangular annex with a shimmering golden façade that changes appearance depending on the weather conditions it reflects. The building has been a great success, helping to revive a central location in the town and attracting a surge in library visitors.

Schmidt Hammer Lassen Architects's design for the ten-storey Aberdeen University Library in Scotland also plays with light. Their goal was to come up with an exterior that would 'shimmer during the day and glow softly at night, creating a luminous landmark for Aberdeen', which they accomplished with an irregular pattern of insulated panels combined with high-performance glazing.

Light play is also a theme in the exterior design of the Library of Birmingham by Dutch firm Mecanoo. The library façade is made of transparent glass, decorated with elaborate interlocking metal circles that resemble filigree work.

One library that has gone in quite the opposite direction is the Kansas City Central Library, which erected an almost windowless, yet surprisingly welcoming ornamental façade called the Community Bookshelf in 2004. Running along the south wall of its parking garage are 22 enormous book spines that measure approximately 7.5 × 3 m (25 × 9 ft) each. Their titles were suggested by Kansas City residents. Among the giant spines are *Catch-22* by Joseph Heller, *Green Eggs and Ham* by Dr Seuss, *Silent Spring* by Rachel Carson and *Fahrenheit 451* by Ray Bradbury.

The interiors of these new big libraries are equally ambitious and innovative in their designs. The University of Aberdeen library, for instance, has a striking asymmetrical tiered atrium that rises diagonally to a giant central skylight, taking a traditional architectural element and playing with it to dizzying

effect. Architectural critic Jonathan Glancey describes the feature as an 'architectural whirlwind' which, viewed from below, resembles a hollowed-out iceberg.

A similarly improbable-looking interior is that of the Seikei University library in Japan. Designed by architect Shigeru Ban, the library centres around multiple transparent isolation spheres, or 'planets' – elevated pods suspended or rising from columns in the central atrium. They are provided so that library users can have animated group discussions without disturbing those who prefer to study silently.

In Tokyo, the Musashino Art University library, designed by Japanese architect Sou Fujimoto, features what seems to be endlessly spiralling bookshelves, described as an 'infinite forest of books'. Passersby outside can see the thousands of wooden shelves, many of which are deliberately left empty, through the multicoloured class that covers the entire exterior.

The distinction between indoor and outdoor space is increasingly blurred in new library design. Architecture firm Karo's open-air library in Magdeburg, eastern Germany, was built in 2005 in a rundown area of the town centre on the site of a former Communist-era district library. The project was planned from

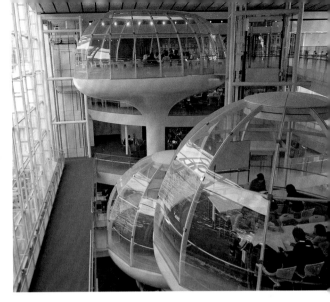

These futuristic 'planets' in the main atrium of the Seikei University library in Japan are elevated, soundproofed pods intended to encourage discussion between students.

the start to be a 'social sculpture', and an initial 1:1 model was built using beer crates with books donated by local residents, who were consulted about the design throughout the process. The resulting library is a three-sided open-air structure framing a central grassy area. It incorporates playful outdoor seating, shelter from the elements, and a stage for concerts, poetry slams and public readings. The library now holds more than 20,000 books on glass-fronted shelves that are accessible to users 24/7.

Another large community library with both indoor and outdoor elements is the children's library designed by Belgian firm BC Architects for the town of Muyinga in northern Burundi. This library is built from the very ground that surrounds it: compressed earth blocks handmade on site form the walls; the roof and floor tiles are baked clay; native eucalyptus forms the roof structure; and rope elements are woven from locally harvested sisal. The building is fronted by an oversized semi-outdoor 'hallway porch', common in Burundian traditional housing since it provides both a shelter from heavy rains and harsh sun as well as a social area for conversation and meeting people. The main reading room includes an enormous hammock of sisal rope suspended from the ceiling as a mezzanine in which the children can recline. The library's goal is to ensure the integration of deaf children into society; eventually it will become part of a dedicated boarding school.

An indoor–outdoor melding of an entirely different kind is My Tree House, a children's wing at Singapore Central Public Library that aims to cultivate interest in environmental conservation. Eco-friendly building materials are used throughout the space, which is decorated with artificial trees and centres around an enormous 'treehouse', whose canopy is made from over 3,000 recycled plastic bottles. Around a third of the children's library collection of 45,000 books focuses on environmental topics such as animals, plants, nature, water resources, weather, ecosystems, recycling and climate change. Young users can also read green-themed eBooks.

'The modern library is no longer solely the domain of the book,' says Mecanoo's Francine Houben, recalling her enthusiastic initial briefing from Library of Birmingham director Brian Gambles. For one thing, large central libraries now incorporate a wide variety of nontraditional services and spaces for the community. The Library of Birmingham houses not only its collection of more than a million books, but also herb gardens, an art gallery, a health centre and a theatre. Moreover, some library collections are no longer predominantly made up of books and other printed material, and the design of their collections storage and reading areas reflects this.

The Nam June Paik library, for example, part of the Nam June Paik Art Center in Yong-In, South Korea, houses primarily video archives and, as such, incorporates many screens for viewing video material, as well as desks and storage for print books. It consists of individual polycarbonate units that clip onto galvanized steel shelves and

tubes. These structures are transportable: they can be dismantled into independent translucent modules and moved to different areas of the building or even outdoors. The library was designed by NHDM's Nahyun Hwang and David Eugin Moon and dedicated to the work of the groundbreaking Korean video artist. 'Inspired by Nam June Paik's artistic processes, the goal of the project was to design a multifunctional spatial device, which redefines the relationship between library users and information,' they explain. In the mid-1970s, Nam June Paik was perhaps the first to coin the phrase 'electronic superhighway' to describe our modern age of telecommunications. It seems fitting that the library named for him exemplifies the unpredictable ways in which big libraries are evolving in the increasingly online 21st century.

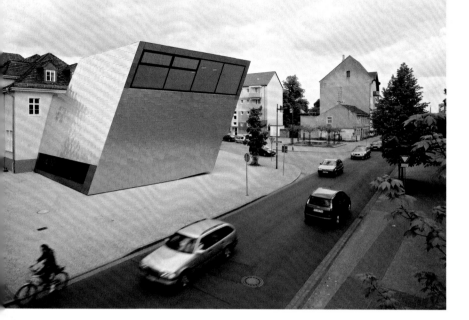

Library station

The shining walls of the new library wing added to a former rail station building in Luckenwalde, Germany, are clad in shingles made of a copper-aluminium alloy. The architects' goal was to create a public library that was also a piece of abstract public art, and to bring new life to a run-down area of town.

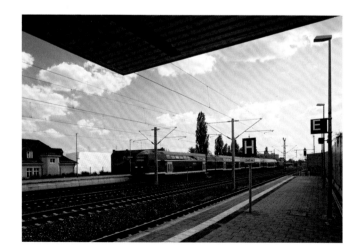

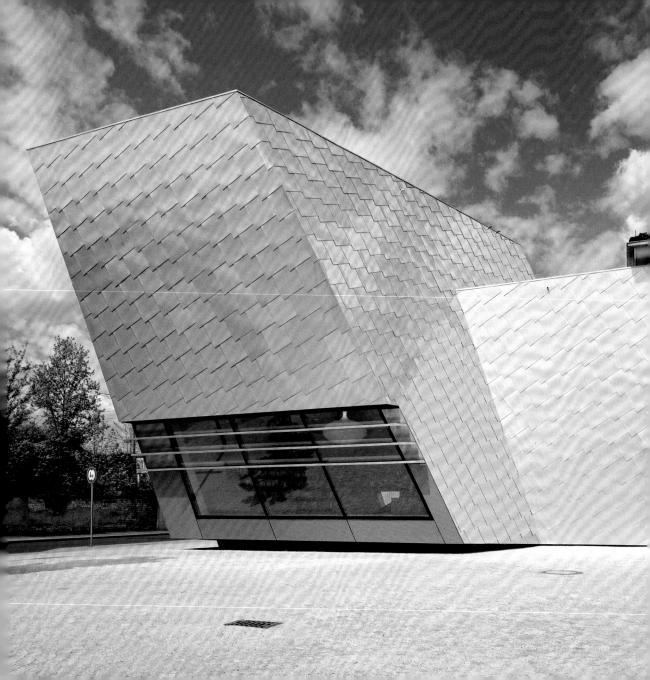

The Luckenwalde library also
provides facilities for children
in welcoming and colourful
surroundings.

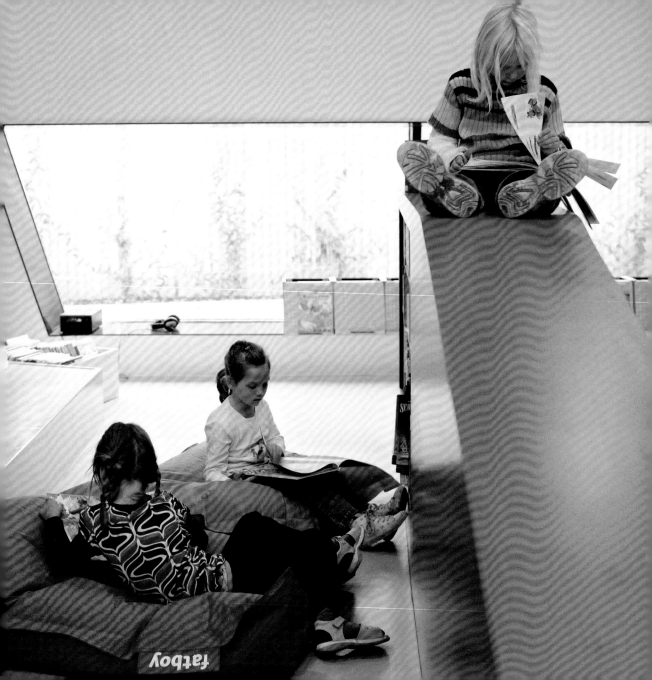

Library of the future

The futuristic Nam June Paik video
library in Yong-In, South Korea,
shows how far some libraries have
evolved from the traditional model
of the bricks-and-mortar building
housing row after row of books on
shelves, and challenges assumptions
of how users interact with libraries.

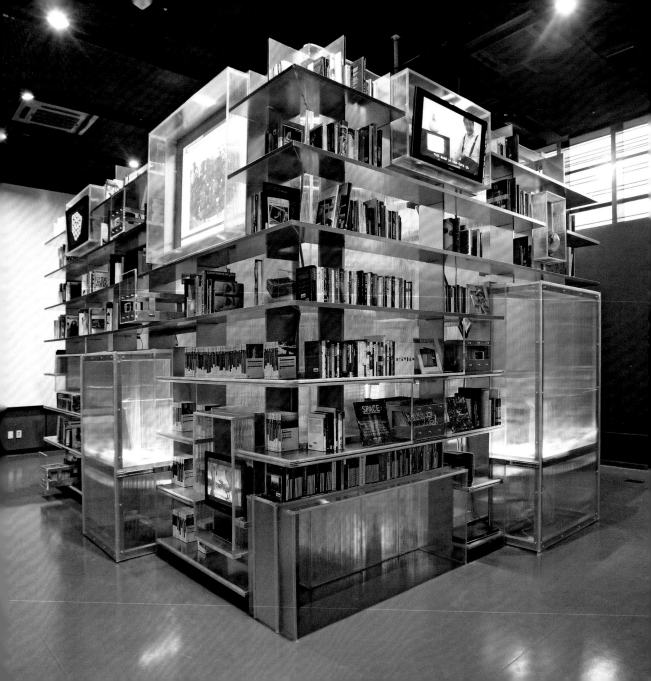

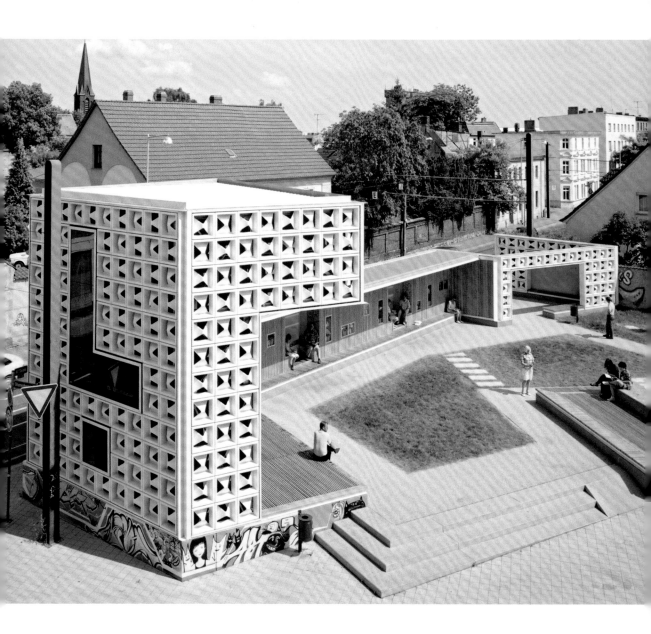

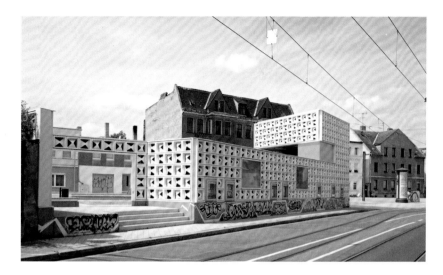

Open to change

This open-air community library in Magdeburg, Germany, was built on the site of a derelict former district library. It is open 24 hours a day and operates on an honesty basis, with no registration necessary. The exterior was partly recycled from a 1966 modernist façade that was removed from the Horten warehouse in Hamm. Behind it, the sheltered inner perimeter incorporates inviting seating and a stage for performance.

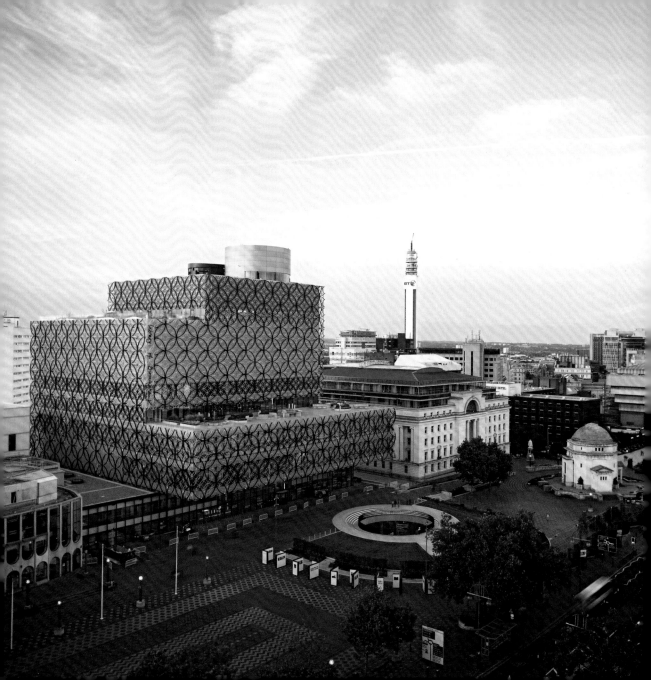

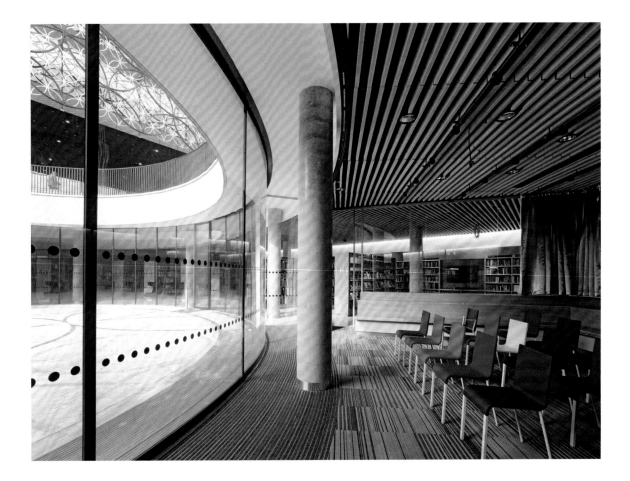

Palatial public library

'Our dream is to create a People's Palace,' says
Mecanoo architect Francine Houben of her firm's
design for the Library of Birmingham. The
'palace' is a 35,000 m² (115,000 ft²) glass and metal
building with an elaborate façade and a large
subterranean level below the city's Centenary
Square. It also houses a community health centre,
exhibition halls, cafés, lounge space and a 300-seat
auditorium shared with a neighbouring theatre.

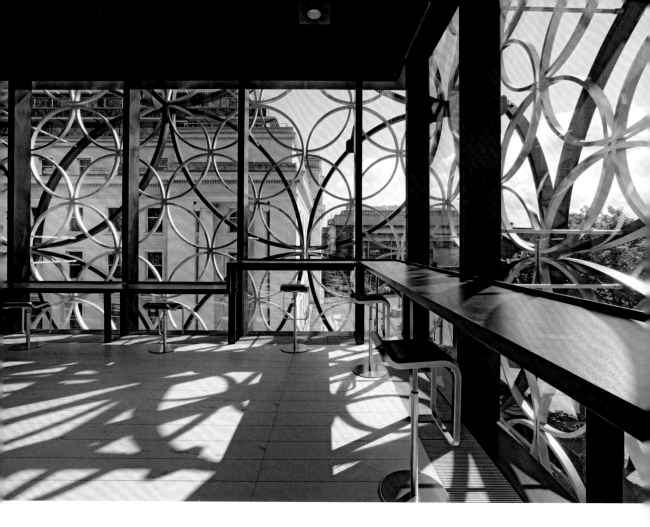

The intricate façade casts a pattern of fleeting circles
and shadows over a reading area, yet still allows
views of the city skyline through the windows.

The main materials and colours used throughout are natural stone, white ceramic flooring, oak, Mecanoo Blue (the firm's signature colour), gold, glass and metal. The building also incorporates grey-water systems and ground-source heat pumps for eco-efficiency.

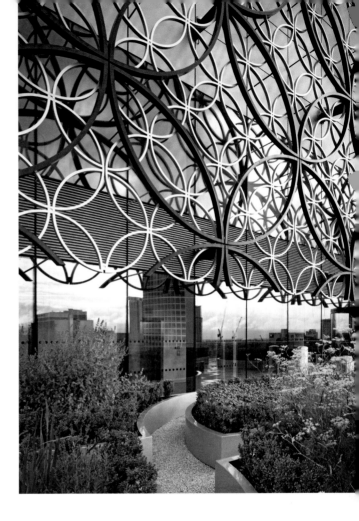

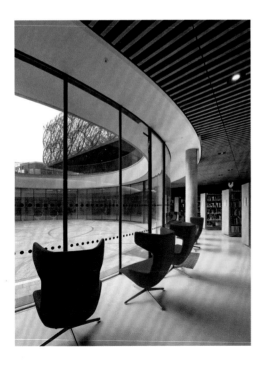

LEFT
Comfortable reading chairs entice visitors on the lower level, which benefits from generous natural light from the sunken amphitheatre. The amphitheatre is intended to be used as an informal outdoor performance space.

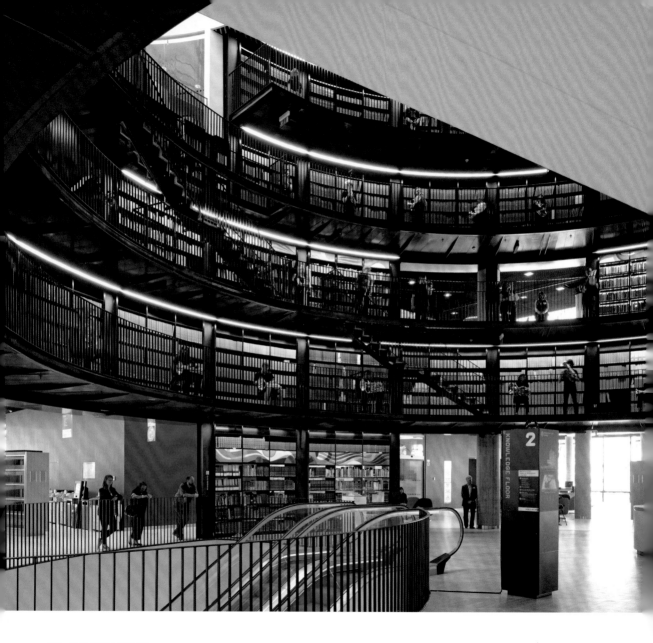

Houben says the design of the Library of Birmingham is 'an ode to the circle, an archetypical form that embodies universality, infinity, unity and timelessness'. The rotundas (opposite) play an important role in routing visitors through the library, and also provide natural light and ventilation. The rooftop rotunda is home to the Shakespeare Memorial Room (right), a Victorian reading room lined with wood panelling salvaged from the first Birmingham Central Library.

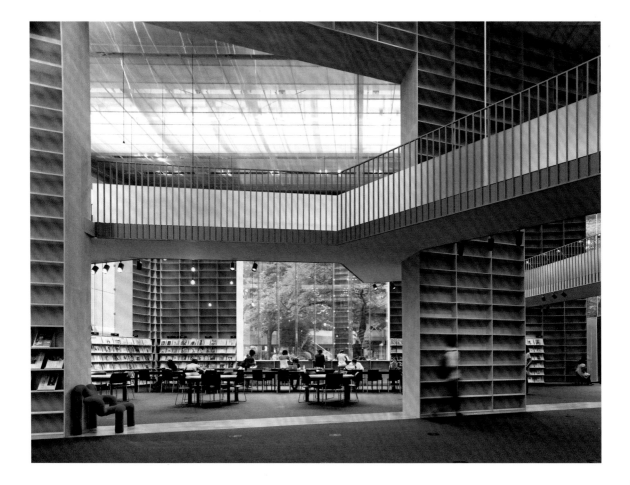

Bookshelves as building blocks

Oversized floor-to-ceiling bookshelves, many yet to be filled, function as room dividers and other structural elements at the Musashino library in Tokyo. Reading areas are linked to each other by small bridges. The building was designed by Sou Fujimoto, who said he was aiming to build a 'simple' library.

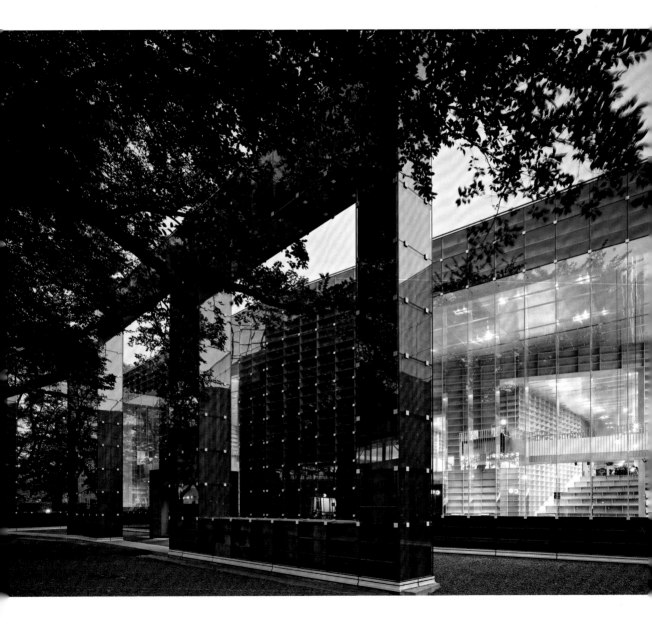

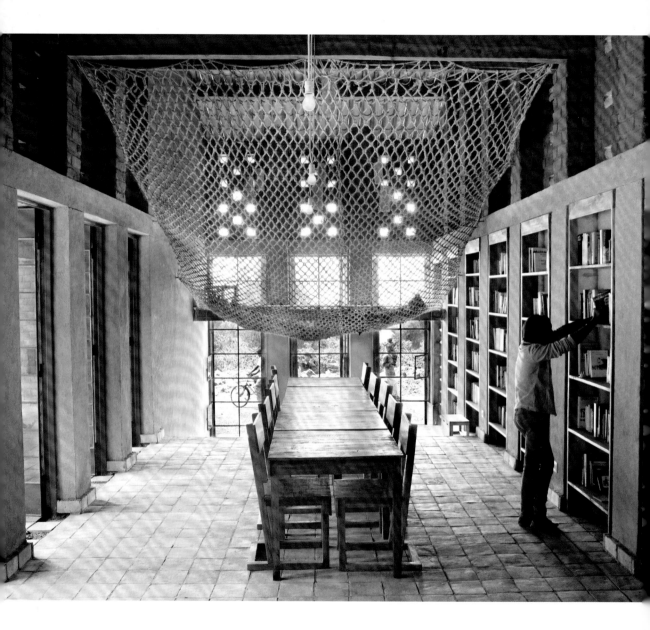

From the ground up

This library for deaf children in Muyinga, northern Burundi, was constructed from local vernacular materials such as pressed-earth bricks made on site. The continuous cross-ventilation in the elevated interior helps to guide the humid and hot air away.

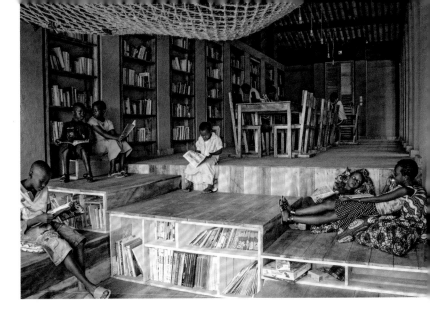

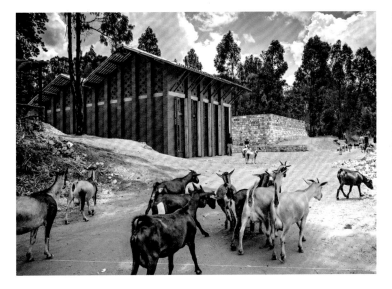

ABOVE AND OPPOSITE
Among its most striking features are huge hammocks made of hand-knotted sisal rope, the product of one of many local micro-industries that bloomed during the project. An elder in Muyinga who was an expert in traditional rope-making harvested, twisted and wove the local sisal plants on site, and taught four other workers these skills; they now use them to earn a living.

My Tree House

In addition to its emphasis on eco issues, at the My Tree House children's library in Singapore, young readers can choose from a wide range of fiction, including many titles related to the theme of forests, and consult the Weather Stump, which charts real-time weather information provided by the Meteorological Service Singapore.

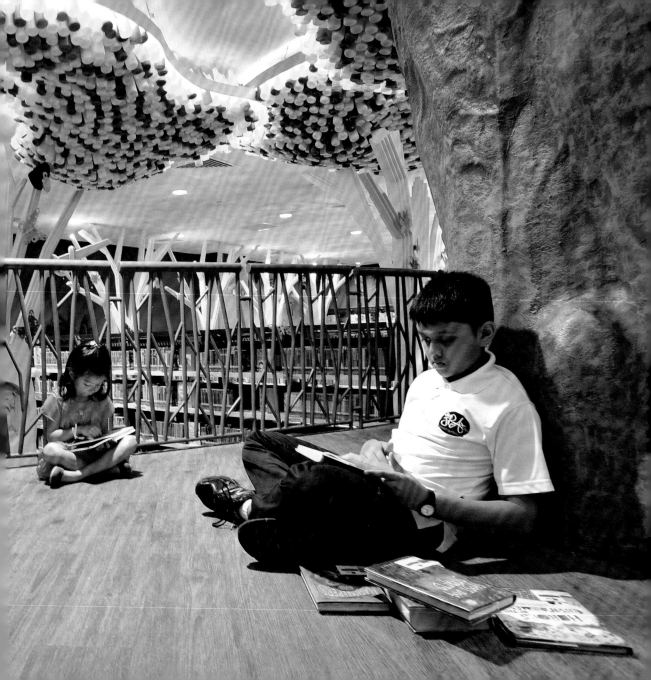

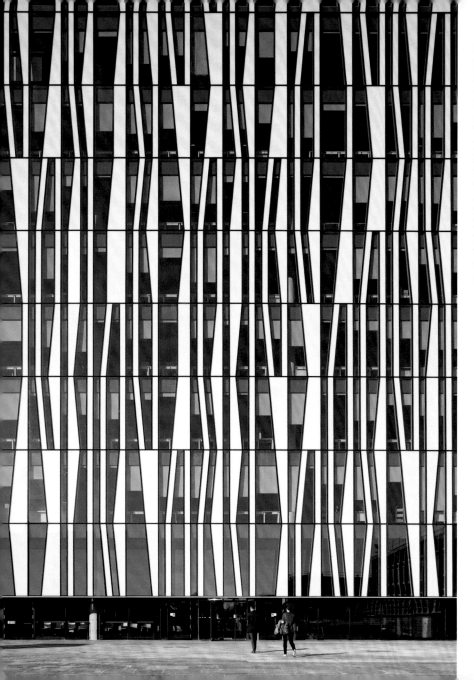

Grand designs

The University of Aberdeen library in Scotland was carefully designed to minimize long-term running costs and energy use. Consisting of an irregular pattern of insulated panels and high-performance glazing, the façade (left) is designed to 'shimmer during the day and glow softly at night', according to its architects, creating a luminous landmark. Inside, the asymmetrical tiered upper floors create a dizzying view from the atrium level (opposite).

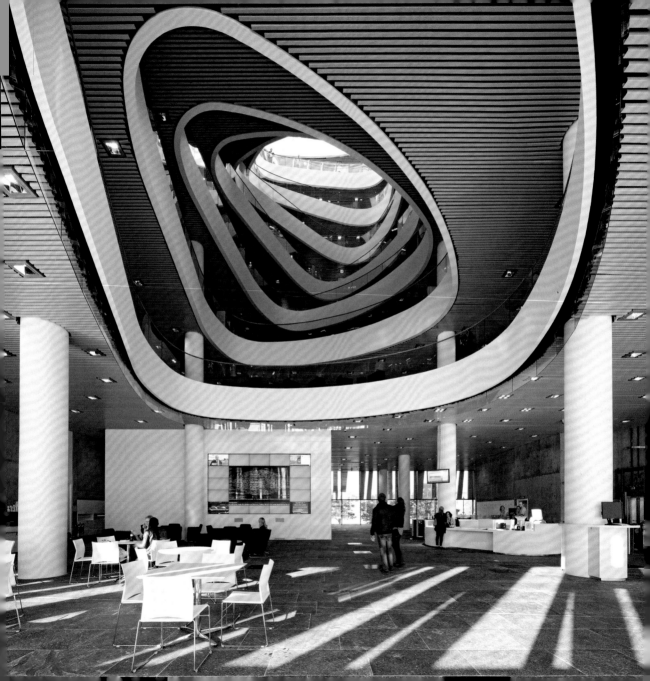

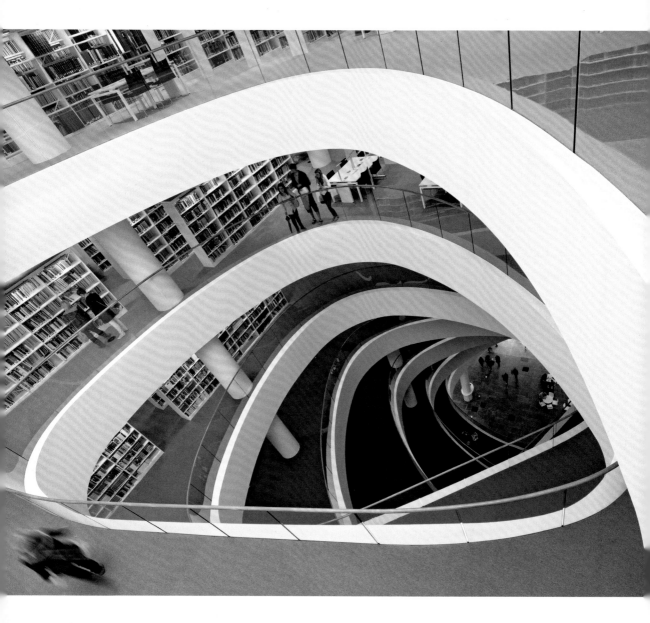

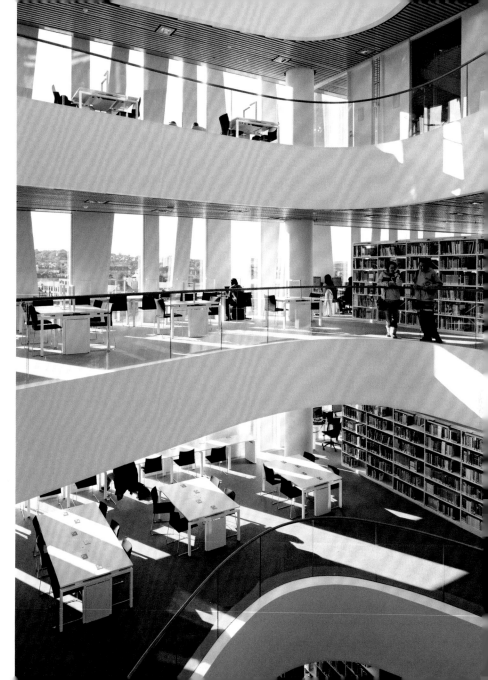

The University of Aberdeen library serves 14,000 students, and houses more than 250,000 books and manuscripts. Its 15,500 m² (51,000 ft²) of floor space offer 1,200 reading areas, as well as archives, historical collections and a rare-books reading room.

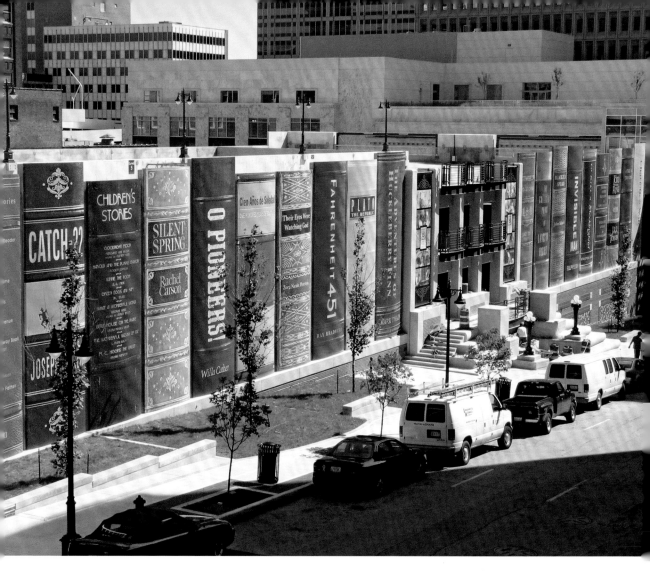

The Community Bookshelf

The giant book-spine decorations on the façade of the Kansas City Central Library are made of signboard mylar overlaying pre-cast concrete panels and an aluminium substructure. They feature 22 favourite titles proposed by local readers.

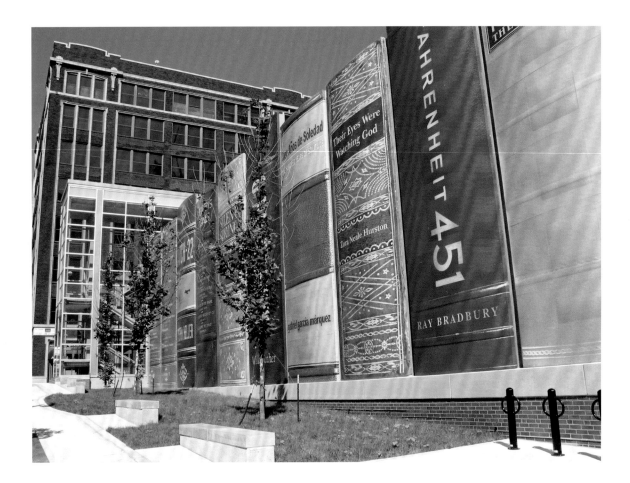

5.
Home Libraries

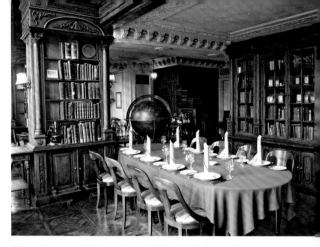

The quintessential wood-panelled stately home library at what is now Café Pushkin, Moscow.

T here is no library more personal than the collection of books we keep at home. These days this collection is just as likely to be spread throughout the home as kept in a single room: the surge in creative bookshelf and bookcase designs over the last few years means that various sections of the home library can be put on attractive display in disparate areas of the house. Still, there is something wonderfully romantic and luxurious in having a dedicated home library space, as in the stately homes of old.

The idea of making the library a central rather than peripheral part of the home is the key concept in the design of Korean architects Moon Hoon for the three-storey Panorama House, built for two teachers and their four children in Chungbuk, South Korea. The design brief was for a home in which the children could play, read and study; the lower floors were to be primarily for the children, and the upper ones for the parents. The central area is a multifunctional space, combining staircase, bookcase and even a built-in slide.

Making a reading space fun for children is also the aim of the Red de Lectura/Reading Net from Madrid-based PlayOffice, run by designers Judith and José Carlos Francisco Baeza. Meshed fabric is suspended across the open gallery of a traditional formal library in

a Madrid home, creating a place for lounging and reading. 'The challenge was to encourage the children of the family to use this space, while still fully respecting the architecture and décor', says Judith Baeza. 'With these constraints we chose to float the children.'

The most striking feature of furniture designer Sallie Trout's Jackalope Ranch in Austin, Texas, is its three-storey, 12 m (40 ft) high vertical home library by architects KRDB. Painted white, it also acts as a light well for the lower parts of the house. Although the most frequently read books can be reached from the adjacent stairs and landing, those on the higher powder-coated steel shelves are only accessible via a bosun's-chair chain-hoist

of the sort most often seen on construction sites; it is raised and lowered via remote control. Another innovative American home library, designed by Travis Price as a writing space for anthropologist and author Wade Davis in Washington DC, incorporates a 5 m (16 ft) dome containing books, which are accessible only via a ladder. Except for a central skylight, the library is windowless, like a monastic cell: Davis specified that to aid his concentration he did not want to be able to see outside.

Today's home libraries are reading sanctuaries, places to retreat from the more chaotic, group-themed spaces of the rest of the house. One beautiful example is the library of the curvaceous Tea House, built by Archi-Union behind their Shanghai office, incorporating salvaged parts of a collapsed warehouse roof. The focus of the calming yet industrial-inspired space is a large tree whose trunk is incorporated into the balcony, and whose branches, behind an enormous indented window, seem to reach into the library itself, inviting contemplation.

The home library has traditionally been a comfortable area inside the house, but there is now a growing trend for extending living space by building new, smaller buildings in otherwise unused space in back gardens, rather than adding conservatories and extensions or even converting roof space. The library studio by British firm 3rdSpace, for example, is not only quick to build, but also fully demountable, allowing it to be 'flat-packed' and moved wholesale if the owner relocates in the future. The installation takes only five days to complete on site, including fitting out the walls with Vitsoe shelving. Design studio Nendo's wooden Book House on the small island of Shikine-jima, Japan, takes a similar conceptual starting point, using bookshelves to clad the walls.

These stand-alone home garden libraries can be elaborate structures built on multiple levels. In Mjölk Architekti's wooden garden library in Zadní Trebán, Czech Republic, the books and reading room (with fireplace!) are on ground level with a sleeping area on the second. The roof also opens, allowing the top of the building to be used as an astronomical observatory. At the opposite extreme is Danish firm Dorte Mandrup Arkitekter's tiny, jewel-like wooden Read Nest, which, though offering less than 10 m^2 (32 ft^2) of floor space, cleverly manages to incorporate generous bookshelves, as well as a work table and a bed. Thanks to innovative designs such as these, it is not only possible to have your own home library – but also for that library to be your second home!

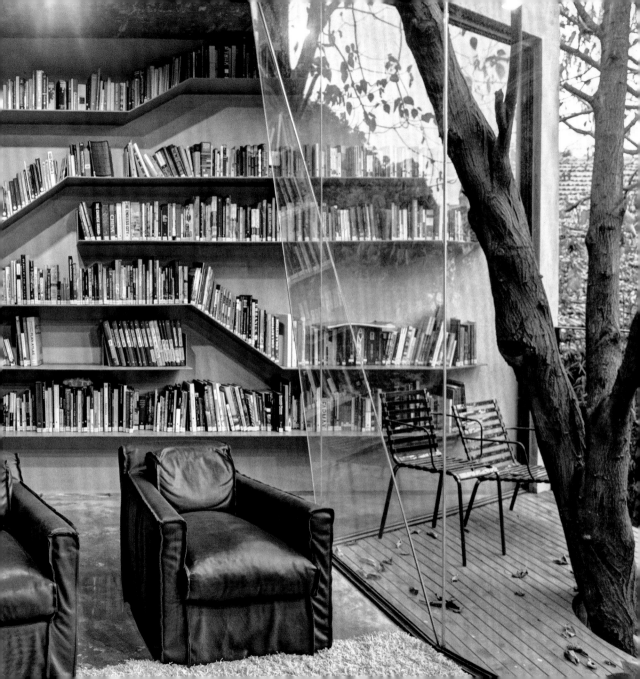

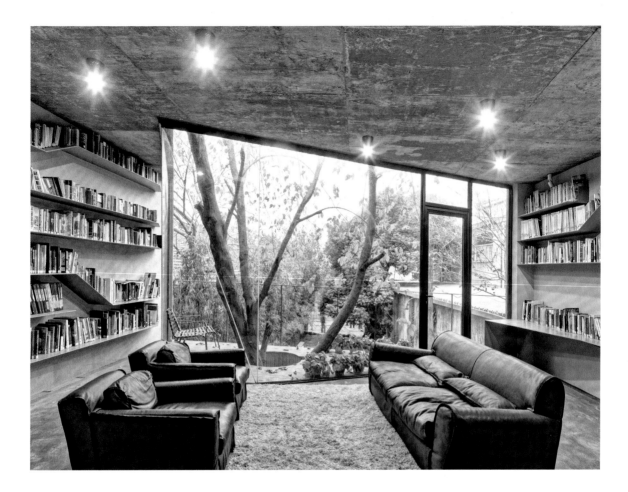

Tree house, Tea House

The Tea House, a private residence in the back garden of Archi-Union's Shanghai offices, features a first-floor library with a triangular balcony built around a mature tree, and an angled window that gracefully accommodates its jutting branches.

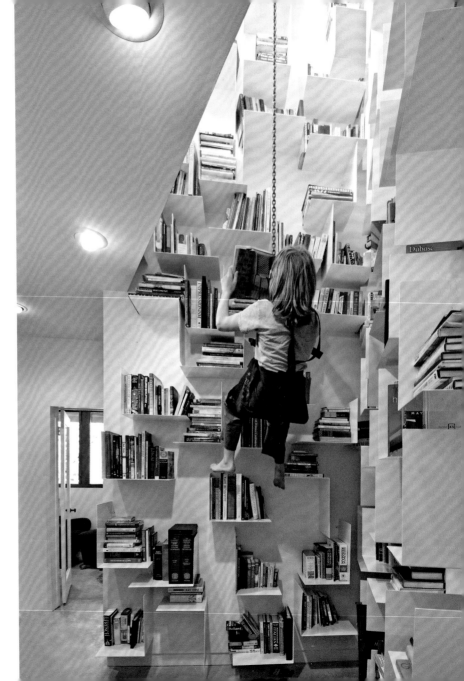

Books in space

In a playful and ingenious use
of space, the upper shelves of
the enclosed library at furniture
designer Sallie Trout's Texan
home are only accessible via a
special hanging bosun's-chair
contraption.

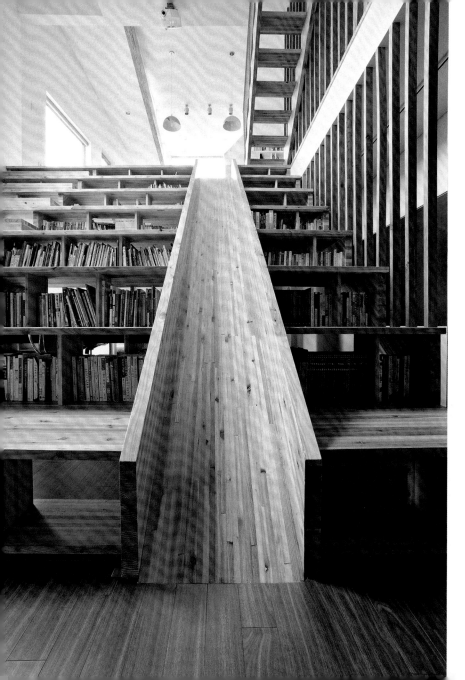

Step, read and slide

This Korean home library designed by Moon Hoon is stepped to provide extra seating and also incorporates a slide, which the architects report is just as popular with the parents in the house as it is with the children. The book storage under each stair is accessible from both the front and back.

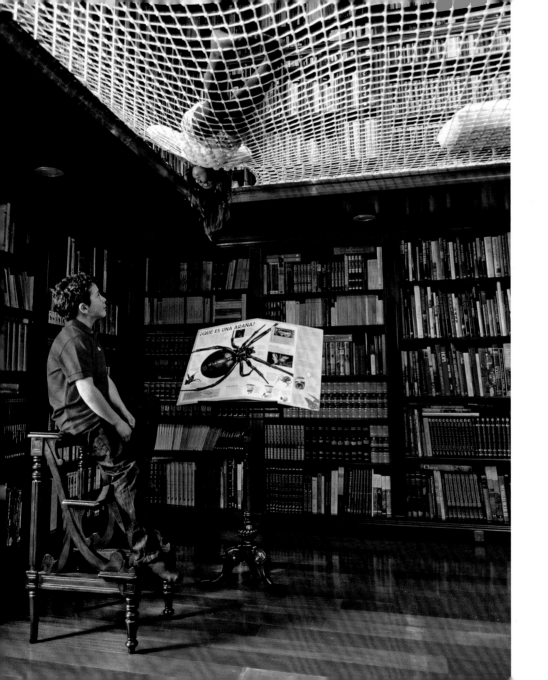

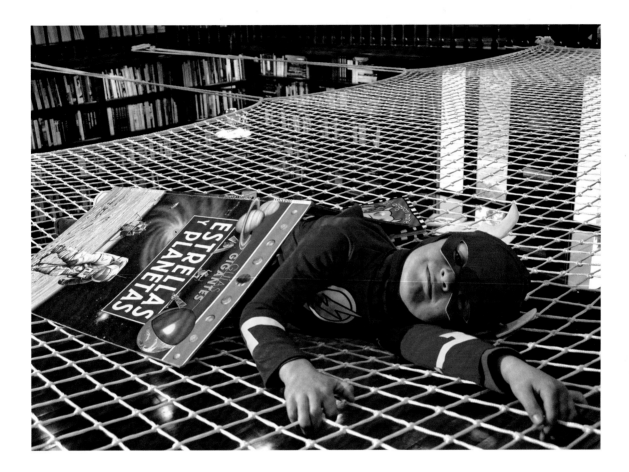

The Reading Net

Madrid-based PlayOffice's Red de
Lectura measures 21 m² (69 ft²) and is
fastened to the upper gallery railings
of this traditional wood-panelled
home library with ropes – no screws
or drilling are required. Its designers
call the result a 'very serious game'.

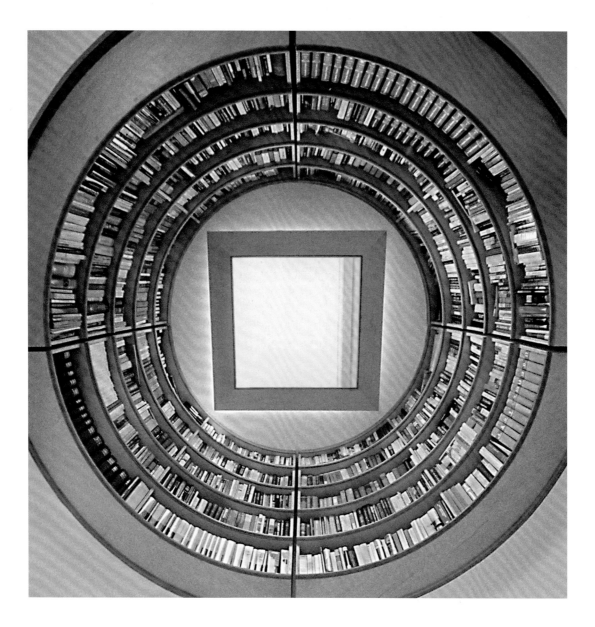

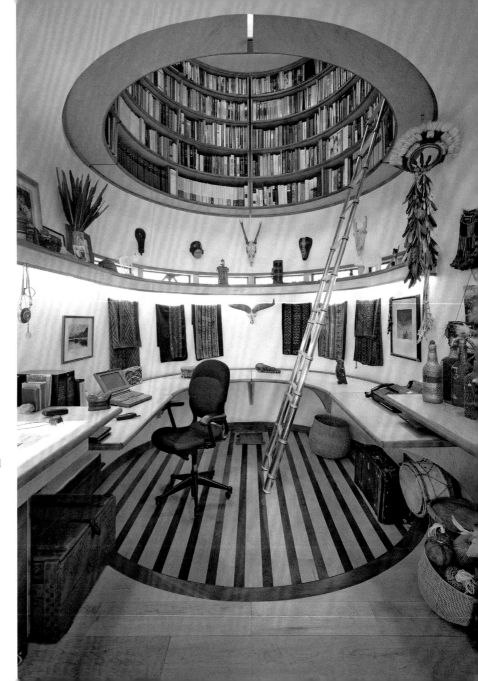

Temple of books

'The original idea I had was to put the books that meant the most to him over his head at all times, floating, above and in his head as his own, very personal lyric,' says designer Travis Price of the home library he designed for Wade Davis in Washington DC. 'The dome shape above was a tholos, the shape of a pregnant woman's womb, similar to the rotunda of the oracle's temple at Delphi.'

The Read Nest

The Read Nest, by architects
Dorte Mandrup, was designed
for the back garden of a
holiday home in Sealand,
Denmark. Despite its small
size, it incorporates a table
and a single bed as well as a
wall of bookshelves, allowing
it to be used for both sleeping
and working. The interior is
clad in waxed birch plywood,
the exterior in thuja wood.

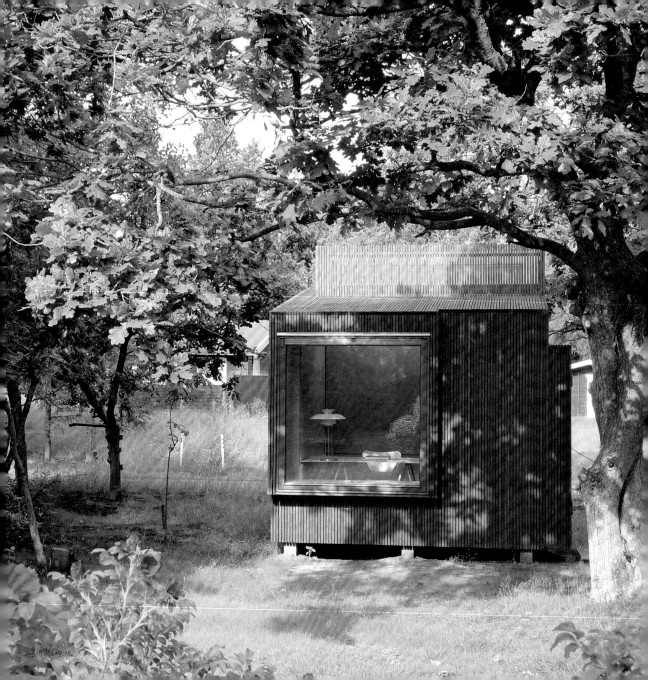

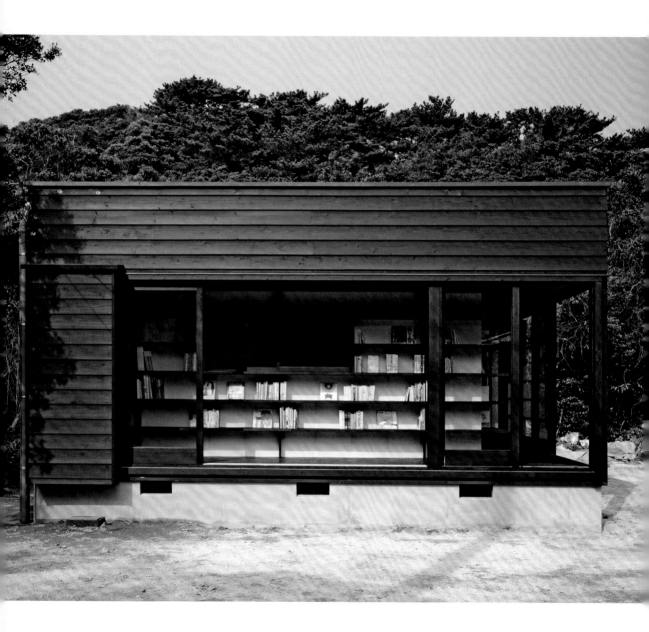

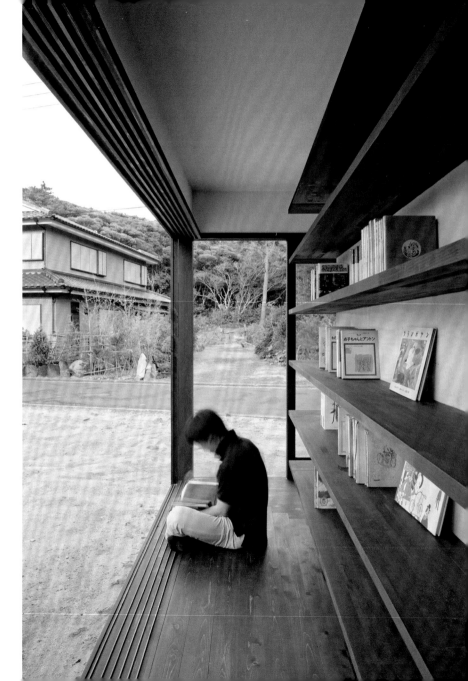

The Book House

The semi-transparent backing material of the bookshelves in Japanese firm Nendo's garden library allows light in during the day, but also lets it shine through at night. When the outer shutters are pulled back, the books are accessible from the outside. Sliding glass doors offer additional protection from bad weather.

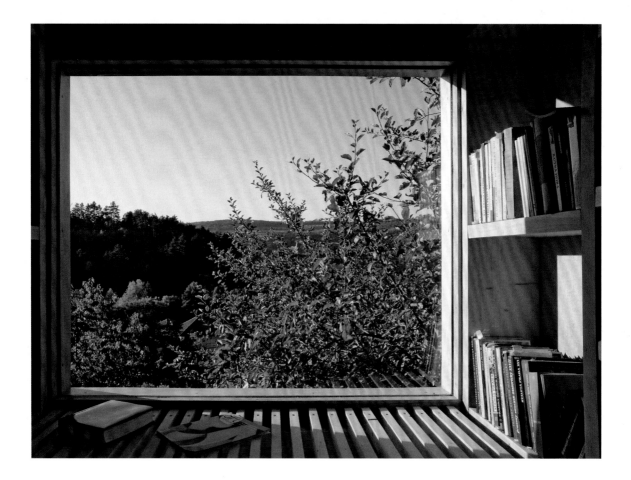

Reading under the stars

The two-storey garden library by Mjölk Architekti in Zadní Trebán, Czech Republic, is made of several types of wood and plywood, and the exterior is covered with fibreglass. Its signature feature is a roof that swings open to allow sunbathing or stargazing.

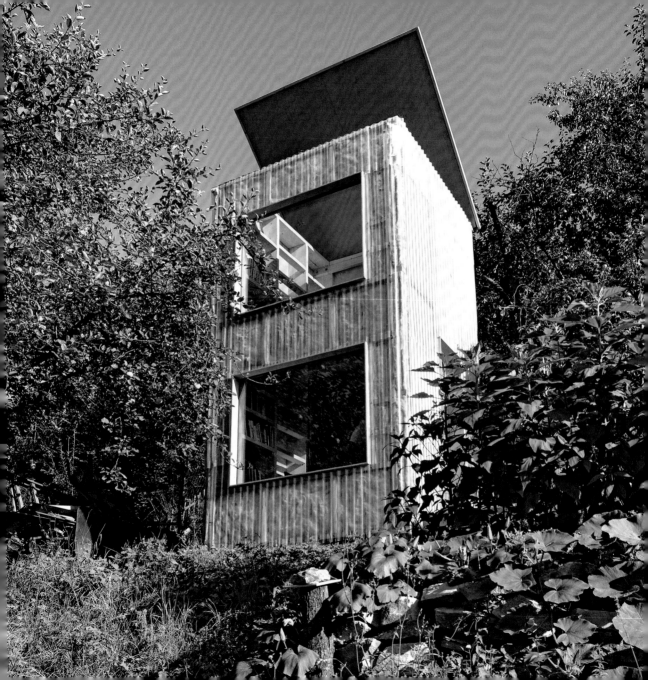

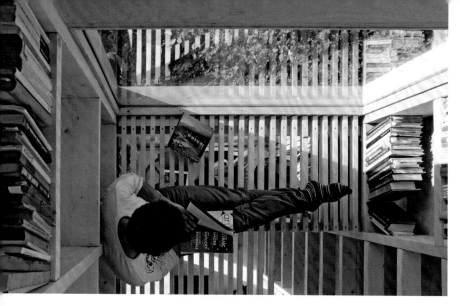

The library is airy and relaxing. Thanks to its rural setting in the Central Bohemian region of the country, it offers readers marvellous views in all directions.

ABOVE AND RIGHT
The bookcases actually provide the main frame of the building and keep the entire structure stable. The cosy wood-burning stove on the ground floor brings welcome warmth on chilly days.

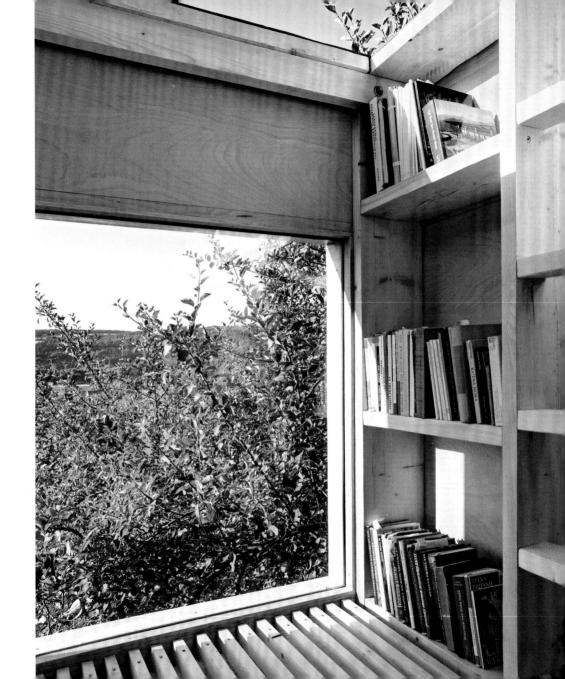

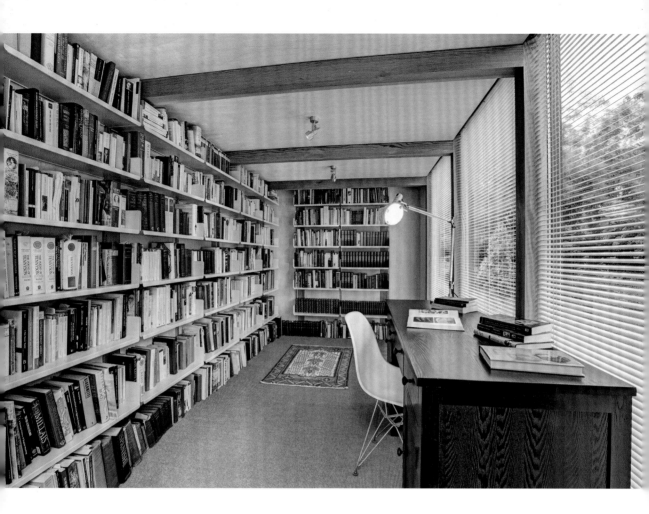

3rdSpace library

The Library, a prefab studio by British firm 3rdSpace, was erected in the Oxfordshire garden of a professor of literature. The interior features white-tinted birch plywood and the exterior cladding is black Thermowood. Modern insulation technology ensures a comfortable room temperature.

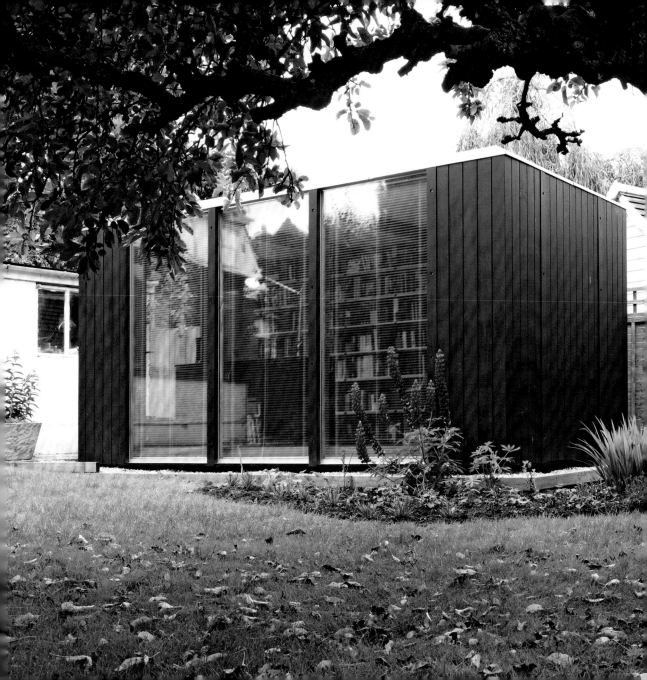

6.
Mobile Libraries

Mobile libraries – carried by road, rail, sea or by hand – have been with us for hundreds of years. 'Circulating library' boxes, for instance, were used as part of the Seaboard Airline Railway Free Traveling Library System in half a dozen south-eastern states in the US between 1898 and 1955. A 21st-century incarnation of the concept is AsiaLink's Arts' project The Bookwallah, a 'roving international writers festival' founded in 2012. Five writers tour Australia and southern India by train, accompanied by six specially designed mobile library cases bound in kangaroo hide and filled with hundreds of books. At each stop – everywhere from the National Centre for the Performing Arts in Mumbai to Platform 9 of the Chennai Central Railway station – the writers set up their library cases, give talks about literature, chat about books with passersby, and gradually donate all the volumes they are carrying to local libraries.

The Uni Project in New York City is one of the largest local mobile library programmes, setting up pop-up, open-air reading rooms in plazas, parks and other public spaces throughout the city. Its creators Sam and Leslie Davol launched the first Uni reading room via a crowdfunding campaign in 2011; since then it has appeared frequently around the city, with a focus on emerging public spaces and neighbourhoods underserved by public libraries. Uni reading room kits have also been shipped around the world. Books in the Uni Project libraries don't circulate: the goal is to encourage communal reading in public, with people enjoying books together in the vicinity of the pop-up library itself. For this reason, the organizers have chosen books that work well for quick browsing: short fiction, art books, poetry and lots of picture books. Some collections are curated by individuals or local organizations: the Uni selection assembled by the Uprise Books Project, for instance, features books that at some point have been banned in the US, including Maurice Sendak's *In The Night Kitchen* and Dr Seuss's *The Lorax*.

Epos is a library boat that has been serving the western coast of Norway for more than 50 years. Funded jointly by three county library services, the 26 m (85 ft) boat carries around 6,000 books during the autumn and winter months, regularly visiting around 150 small, remote coastal communities. In the summer, it operates as a sightseeing boat to serve the tourist trade. A similar sea library service has operated in Pargas, Finland, since 1976. This library is carried on a marine rescue boat, which can technically be called out at any time to attend an emergency at sea.

Boats of all different shapes and sizes are used to carry mobile libraries. American artist Sarah Peters has brought the concept to the calm waters of Cedar Lake, outside Minneapolis, Minnesota, on a small custom-built raft. Her library does not have a huge stock – around 100 books – but is open to anyone with their own kayak, canoe or inner tube…or who fancies a swim. 'While the lakes are well used for individual recreation, they offer very little collective social experience,' says Peters of her inspiration for the library. Customers tie up alongside the raft and browse the shelves from inside their own boats, borrowing books on an honour system and returning them either to the raft or to boxes on the lake's beaches. The stock is very eclectic, including books on snow people, entropy, weeds and the TransAlaska pipeline.

In rural Laos, Community Learning International operates three book boats that serve some 10,000 children in dozens of otherwise unreachable villages on the Mekong and Ou rivers. Each boat carries around 1,000 titles in the Lao language that are lent to children overnight at each stop and returned before the boat leaves in the morning. 'There are no books whatsoever here: exercise books, reading books, notebooks, manuals – none,' says Alexander Robb-Millar, Director of

Development at CLI, of the importance of bringing Lao books, many of them specially published by CLI, to the children in the villages, along with puppet shows, story-readings and other activities to encourage literacy. CLI also distributes 'book bags', each of which holds around 100 books, to rural schools via the book boats and other vehicles, rotating them regularly for a new selection. A similar scheme of rotating mobile library

Started by the US Light House Establishment in 1876, these mobile libraries provided reading matter to isolated lighthouse keepers and their families. The numbered, portable wooden cases held around 50 books and were rotated between lighthouses every four months.

boxes carried by boat once served lighthouse keepers' families in the 19th-century US.

Library boats have also been a success in Bangladesh. The NGO Shidhulai Swanirvar Sangstha operates around 100 boats along the waterways of the country's Chalan Beel region, bringing a range of health and education services to some 100,000 people. Ten of its boats are fully dedicated library vessels with solar-powered wireless internet. Twenty additional school boats have smaller libraries on board. The boats are modified traditional Bangladeshi craft called *noka* that are built to withstand monsoons.

Mobile libraries on bicycles are springing up in cities around the world. The Books on Bikes project in Seattle is one of many schemes that use pedal power to bring library services directly to the community. A member of the team of eleven cycling librarians tows an aluminium bike trailer the size of a steamer trunk, which holds 100 books. It also has a useful umbrella holder to keep books dry when it rains. Books are restocked from the main libraries, and must be returned to them rather than to the book bikes due to weight constraints.

A similar project is operated by Pima County Public Library in Tucson, Arizona. The Bookbike is a three-wheeled adult tricycle that has a large box at the front that opens to reveal bookshelves with several hundred volumes. 'We take the Bookbike out to different locations to give away the books, to give away library cards, to give out information about library programs and literacy projects, as well as bike maps and bike programs,' says Karen Greene, the librarian who runs the project. In its first year of operation, the Bookbike's volunteers rode 250 miles (400 km), talked to 16,046 people, and gave away 11,276 books, all donated or library-retired.

In Brazil, Bicicloteca founder Robson Mendonça pedals a three-wheeled lending library through São Paulo in a bid to encourage reading in general, but especially serving homeless people who live on the streets, since no identification or proof of address is required to borrow books. The library also offers solar-powered internet access. In a single year, the Bicicloteca, sponsored by environmental nonprofit Instituto da Mobilidade, made more than 107,000 loans, including many Braille books. Street Books, a bicycle-powered mobile library for the homeless in Portland, Oregon, is run along similar lines.

To put it mildly, Argentine activist artist Raúl Lemesoff's Arma de Instrucción Masiva ('Weapon of Mass Instruction') is not your average mobile library. The library travels

in a 1979 Ford Falcon that Lemesoff has rebuilt to look like a tank covered in bookshelves. He drives it around Buenos Aires and other Argentine cities offering his stock of 900 books to passersby. The repurposing of a Ford Falcon is symbolic since it was a vehicle used by the armed forces of the country's former military dictatorship. Instead of bringing oppression and violence to the people, it now brings books of all sorts, stocked entirely through private donations.

Another unusual bookmobile on wheels was American entrepreneur Brewster Kahle's now defunct Internet Archive Bookmobile, which offered a digital Print On Demand library. Visitors at stops throughout the continental US could access, download and print (to a surprisingly high standard) public domain books available online.

A number of equally improbable vehicles around the world operate as mobile libraries. Among the most intriguing is the Biblioteca Movil A47 project developed by the Fundación Alumnos47 in Mexico. Architects PRODUCTORA repurposed a Freightliner M2 20K container truck into a deluxe library on wheels. The sides can be opened to create a sheltered, airy reading room, with the books on shelves running the full length of the walls. As well as operating as a library, it also hosts workshops, lectures, screenings, book presentations and readings.

Reading on the beach is a traditional holiday activity, but the increasing numbers of beachside mobile libraries mean that you no longer need to risk your personal copy of Proust falling foul of the sea and sand. Castelldefels, near Barcelona, is one of many locations in Spain where mobile libraries pop up close to the beach in summer months. Its local mobile beach library, on the promenade in the Parque del Mar, has been running since 1992, offering not just books, but also magazines, DVDs and CDs, as well as reading-based activities for children. Libraries at swimming pools, known as 'bibliopiscinas', are also popular in summer months in Spain, as are the semipermanent libraries on Dutch beaches.

The library on wheels at Metzitzim Beach in northern Tel Aviv offers more than 500 books in Hebrew, English, Russian, Arabic and French from its brightly painted cart during the summer. Like most other beach libraries, no library cards are required and there is no checkout process. The beach library is supported by the municipal culture department, whose stated goal is simply to make books more widely accessible to the public.

At the most basic level, mobile libraries are simply carried by hand. In Nepal, the Doko Dai Mobile Library system relies on people carrying cane baskets of books into mountainous villages inaccessible by motor vehicle. In Sabaneta, Colombia, a cart of books known as the Bibliocarreta is carried door-to-door by Jhon Fredy Salazar, who calculates its size carefully so that he can duck into doorways when it rains. 'Our aim is simply to help the local residents improve their education,' says local librarian and project director Oswaldo Gutiérrez. To this end, the Bibliocarreta also visits the town's prison, hospitals and homes for the elderly, and on Sundays it offers books in one of the city parks.

Wherever there is a demand for books, enterprising librarians will find a delivery method that meets the challenges of local geography and infrastructure.

Wheeled libraries for hospital patients were popular in the first half of the 20th century. Here a young rheumatic patient chooses a book from the mobile library in an American children's hospital in 1943.

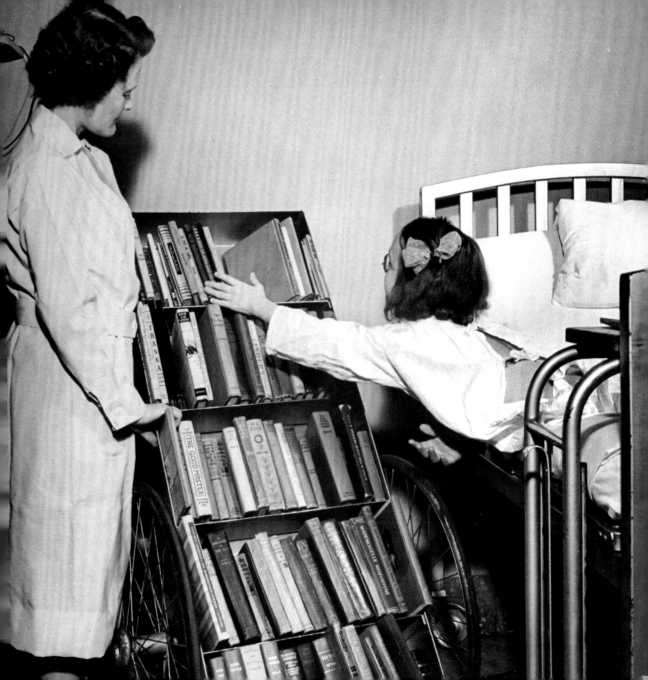

The Bookwallah

The Australian writers who took part in AsiaLink Arts' first 'roving international writers festival' through India in 2012 did not travel lightly, carrying a quarter tonne of books in travelling library cases. The cases were made from Australian materials including kangaroo leather and plantation wood, and built to withstand the rigours of Indian trains. They held pop-up libraries that were set up for the public at each stop along the journey across the subcontinent.

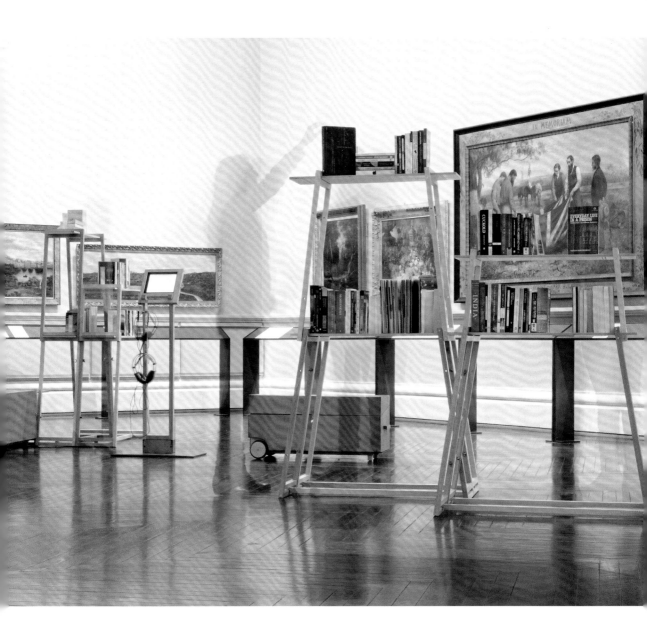

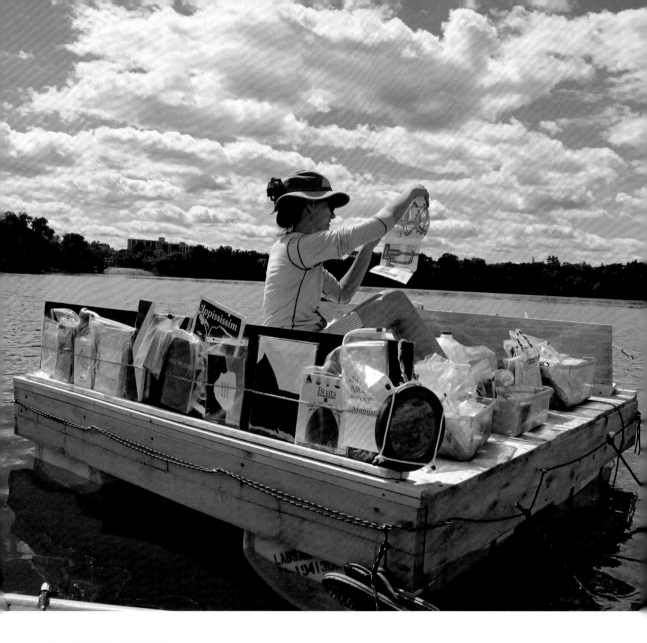

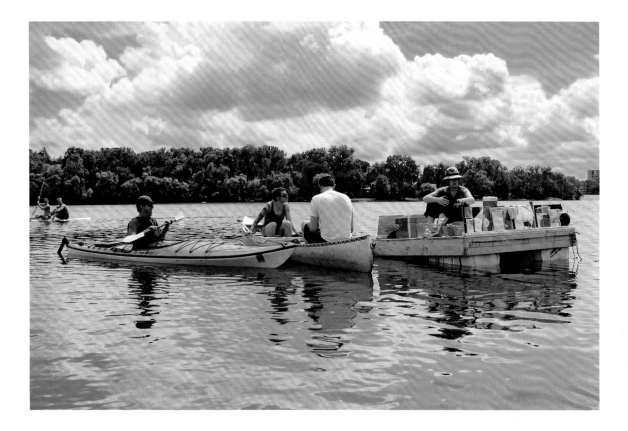

A raft of books

Sarah Peters's floating library
on Cedar Lake in Minneapolis,
Minnesota, is open to anyone
who can reach it via water.
Plastic covers protect the books,
which are lent and returned on
an honour system. She hopes to
expand the library in the future
to provide boatside readings
and lectures.

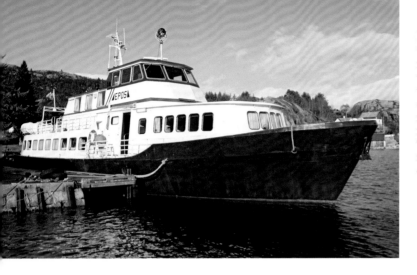

Long-sailing library

This floating library serving isolated communities on the west coast of Norway during the long winter months was established in 1959. The *Epos*, its current custom-built boat, made its first trips in 1963. The crew size varies but always includes a skipper, one engineer/ deckhand and a cook.

The shelves in the *Epos* library boat ares tilted and equipped with an automatic securing system to prevent the books from tumbling off the shelves if the seas get choppy.

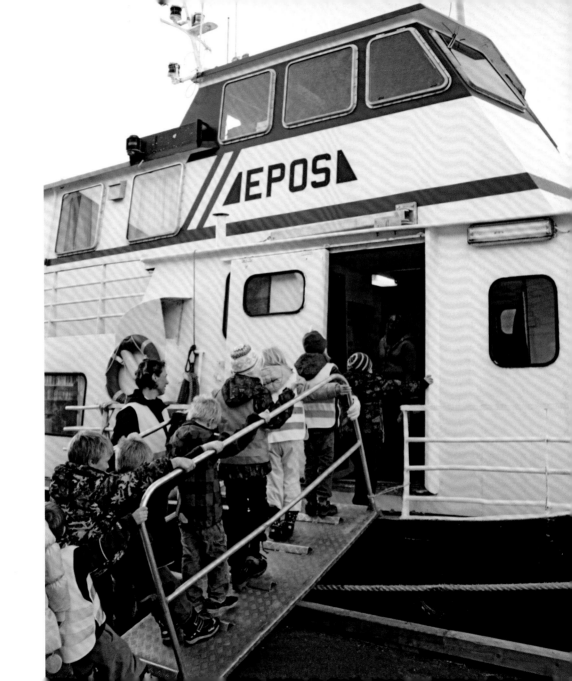

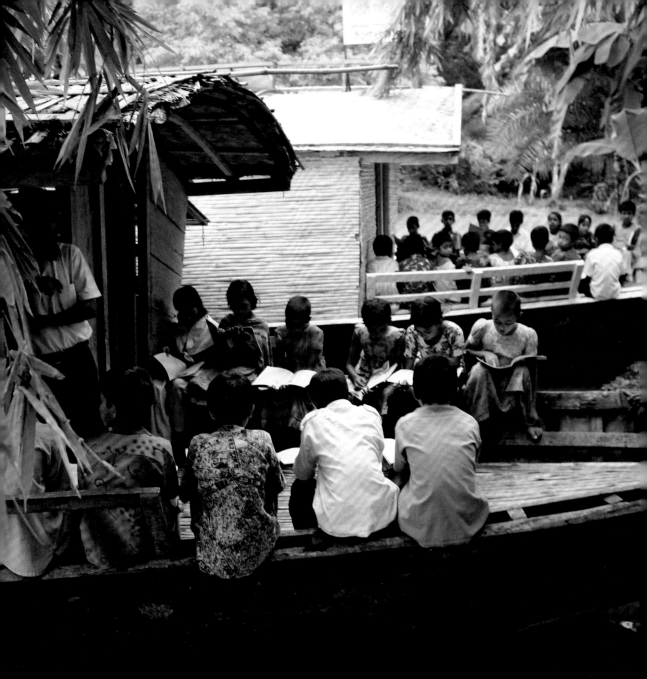

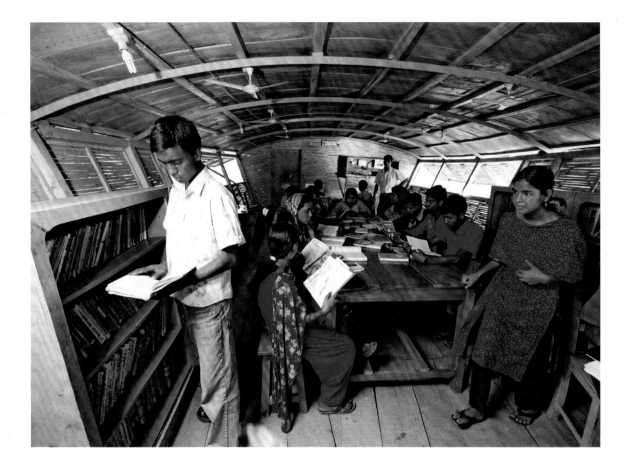

Arks of knowledge

The Shidhulai Swanirvar Sangstha library boats
in Bangladesh encourage children's literacy in
flood-prone rural areas where schools are difficult
to access. In addition to the 1,500 books on board,
each boat also offers computers, printers and
mobile phones. Two boats incorporate classrooms
(above), where literacy education courses are held
for the children's parents in the evenings.

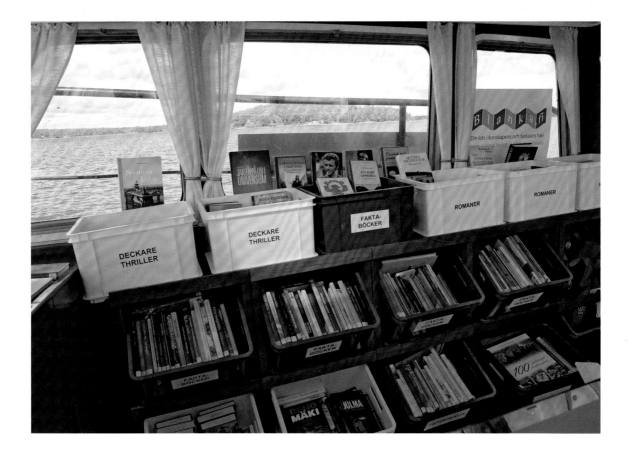

Library to the rescue!

This mobile library on a fully operational sea-rescue boat is based in Pargas in the Åboland archipelago of western Finland. The boat carries around 600 books in plastic boxes, making a dozen stops weekly in the summer and autumn months. Elsewhere in the archipelago, ferries bring municipal library services.

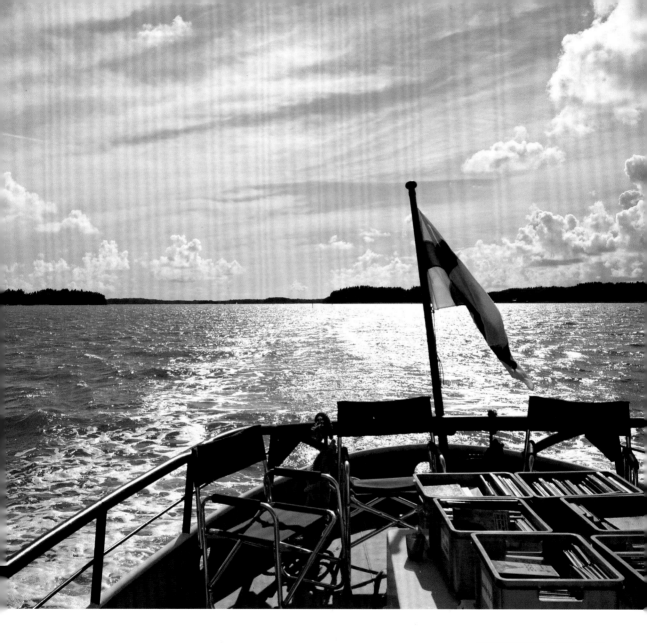

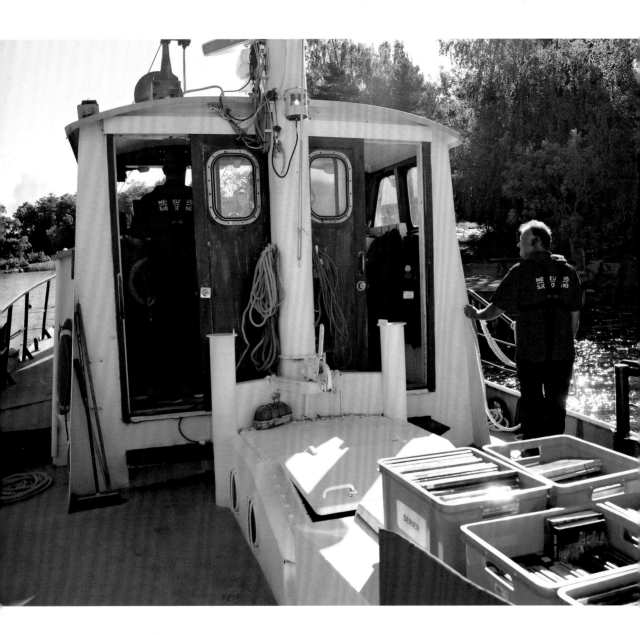

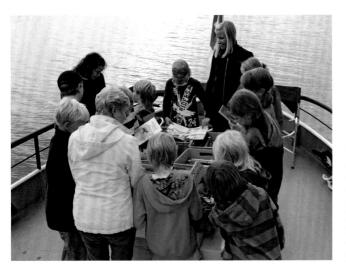

The books are selected by library staff, with a particular emphasis on gardening, fishing and hunting titles, as these are the most popular subjects among library users. Practical considerations also affect the selection: the books must be weighed to ensure the library boat is not overladen.

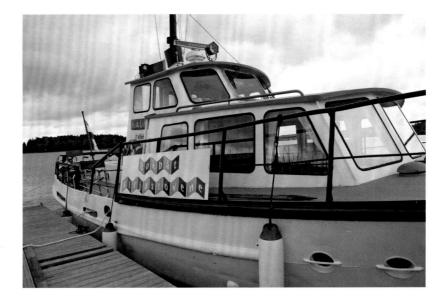

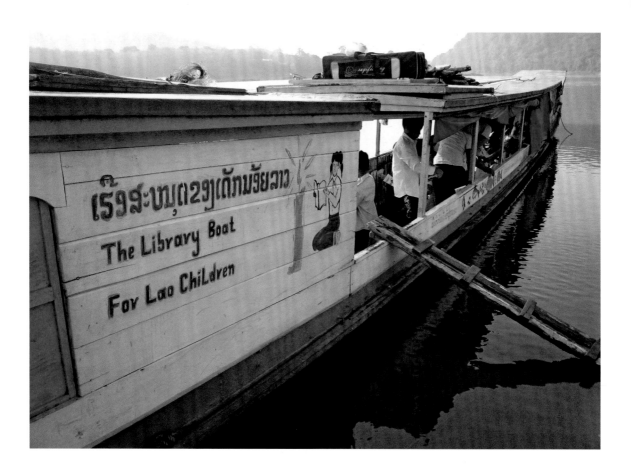

Library boat for Lao children
Each of Community Learning International's library boats on the Mekong and Ou rivers carries around 1,000 Lao titles. At each stop, staff run reading-related games for the children, who can borrow books overnight and return them the next morning before the boat moves on to another village.

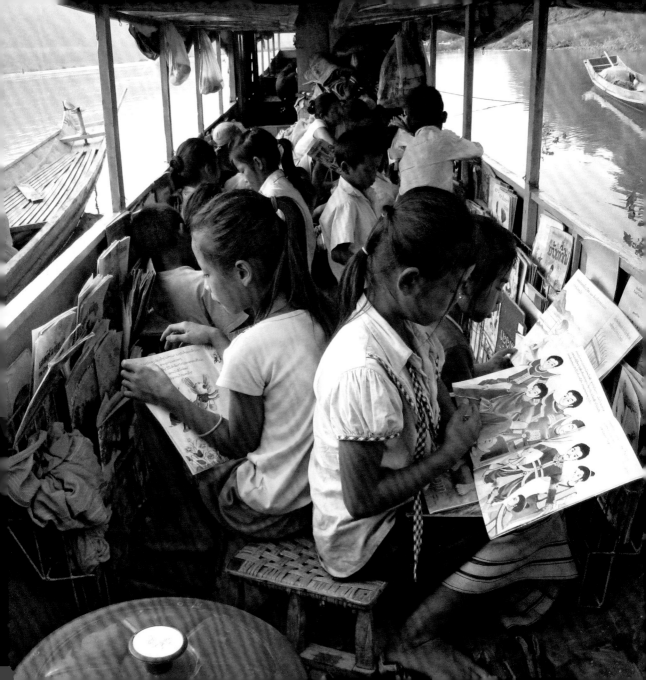

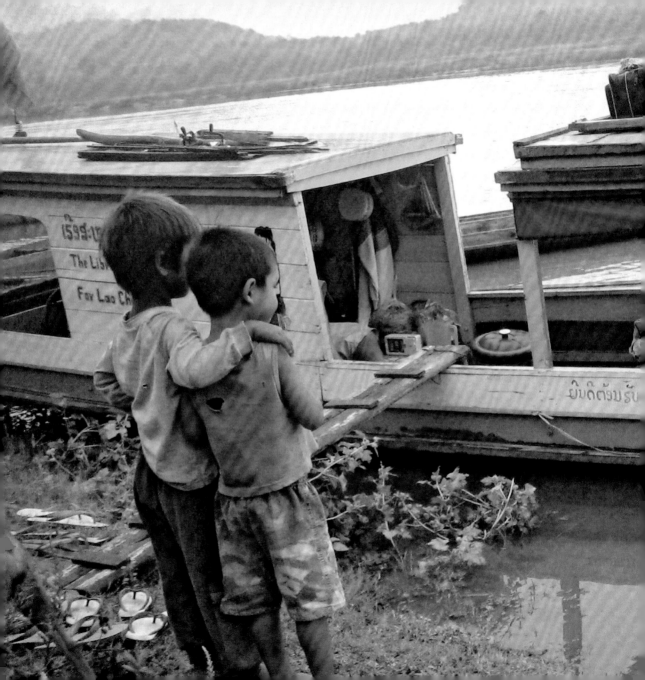

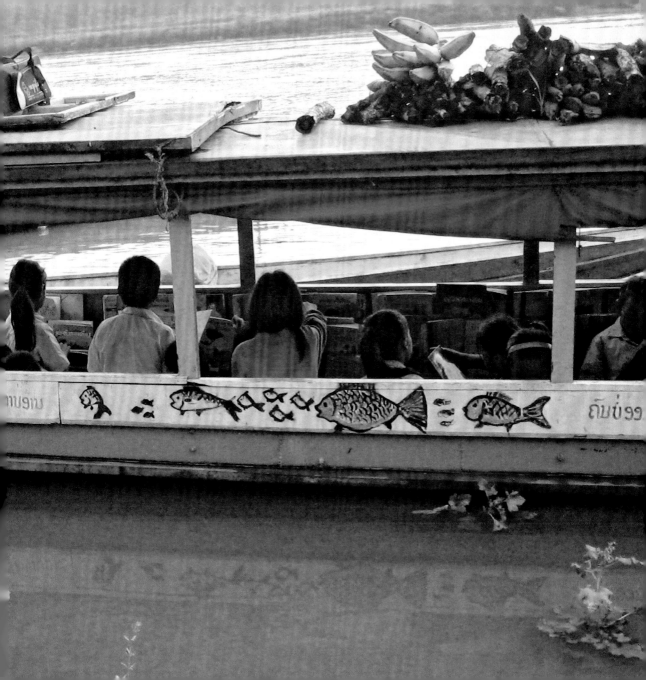

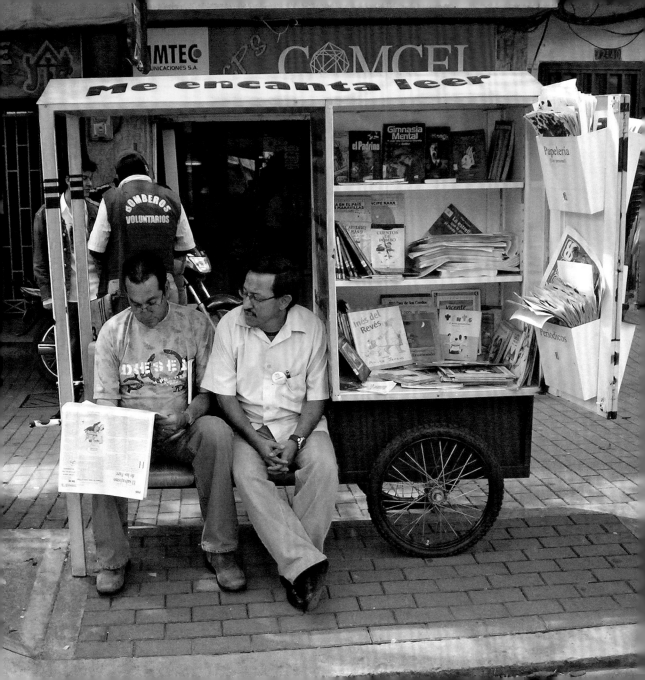

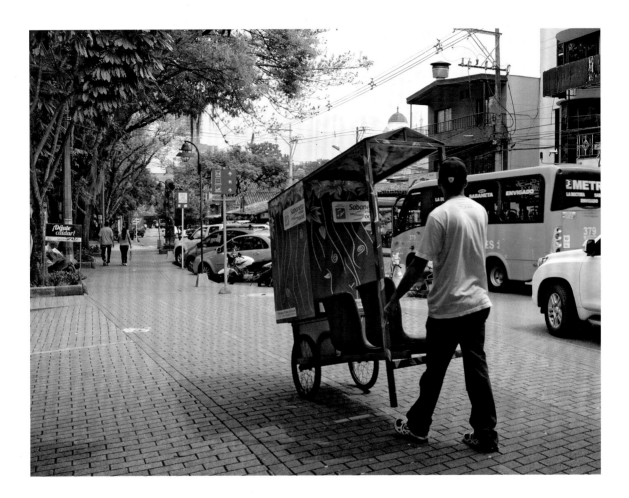

Bibliocarreta

The Bibliocarreta, a door-to-door mobile
library operated by the public library in
Sabaneta, Colombia, carries a selection of 80
books with an emphasis on children's titles.
Project director Oswaldo Gutiérrez says that
initially he had hoped to provide a 'bibliobus',
but costs forced him to scale down his plan to
what he describes as a 'wardrobe on wheels'.

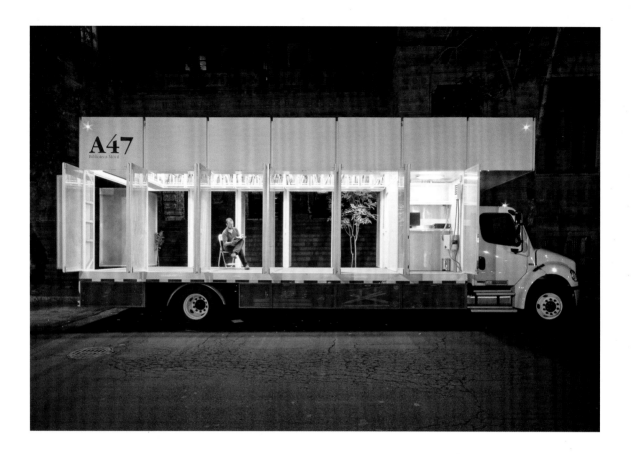

Mobile Art Library

PRODUCTORA's A47 Mobile Art Library travels around Mexico City. The rotating wall–doors are metal sheets with thousands of tiny holes drilled into them to allow light to enter, producing a striking effect at night when the reading area is illuminated from inside.

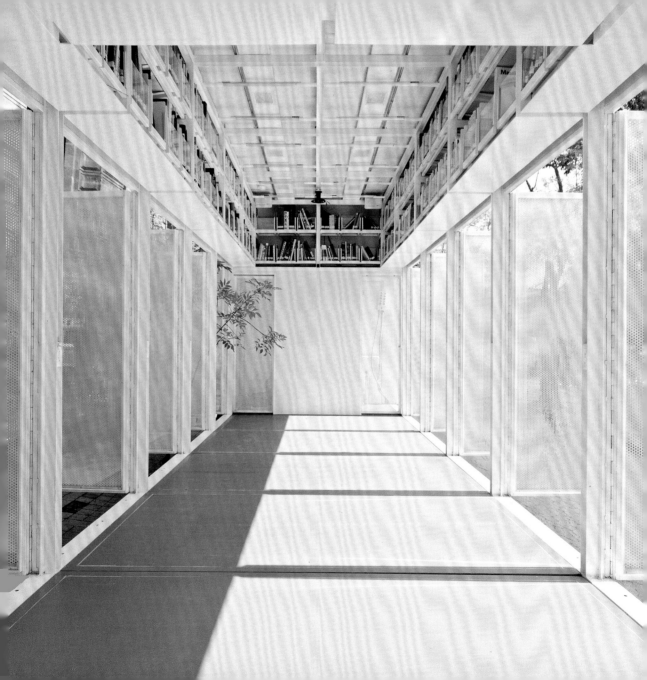

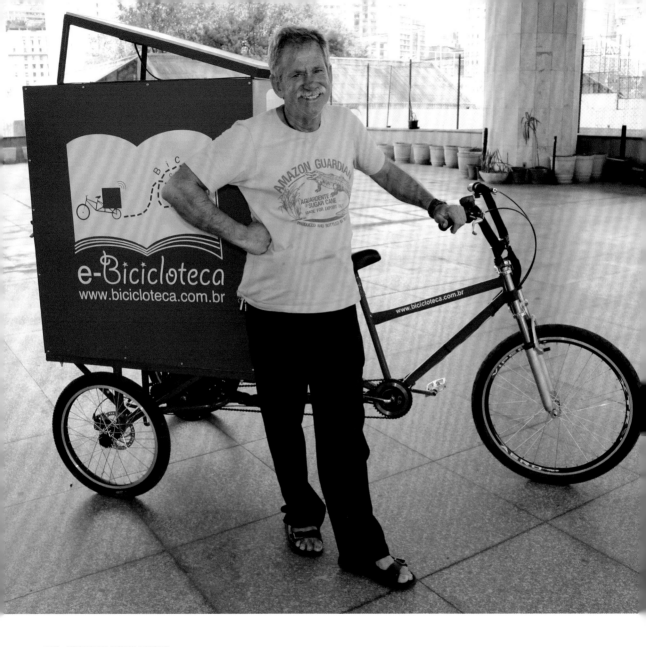

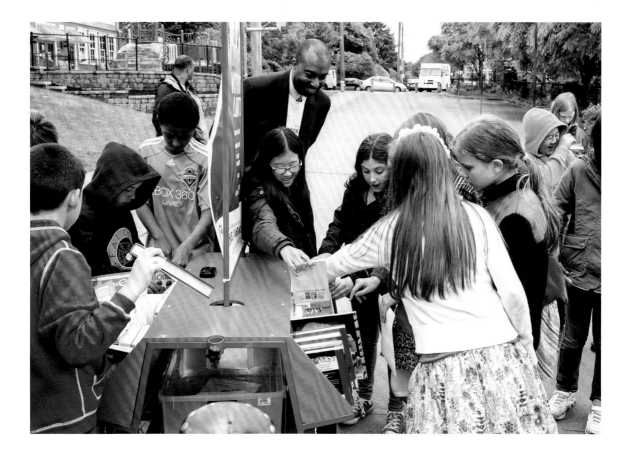

Biblioteca

Founded by Robson Mendonça (opposite), a former librarian who found himself homeless, this library on three wheels serves those living on the streets of São Paulo. No identification or proof of residency is required to borrow books.

Library hot spot

Seattle Public Library's book bike also operates as a mobile Wi-Fi hotspot, allowing readers to sign up for library cards on the spot and borrow books via a specially designed iPad app.

Tucson Bookbike

The Bookbike, operated
by Pima County Public
Library in Tucson, Arizona,
has many different regular
stopping points, including
farmers' markets, women's
shelters and a soup kitchen.

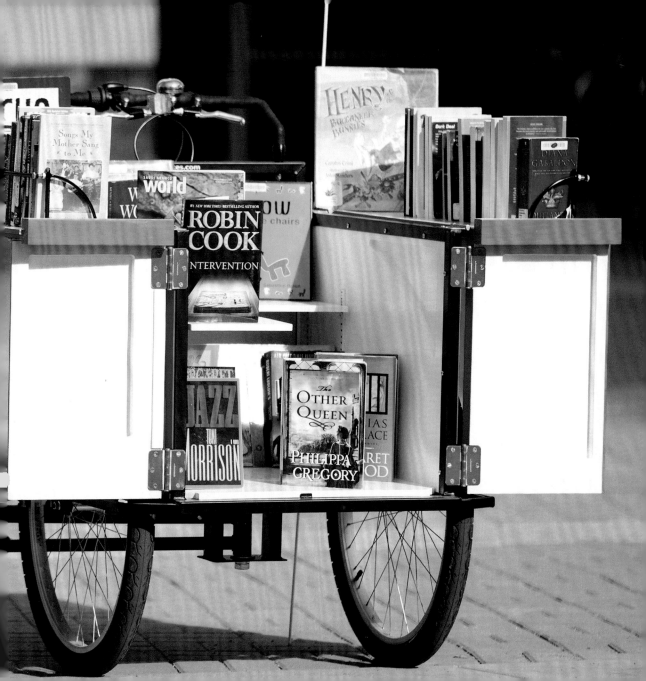

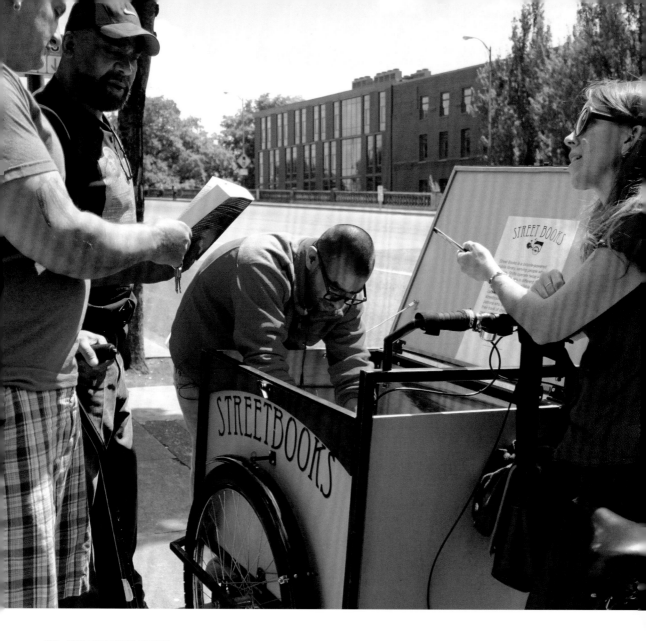

Street Books

Street Books in Portland, Oregon, was established in 2011 for 'people who live outside'. All those using the library are asked if they would like to be photographed holding their chosen book; the pictures then appear on the Street Books website. The project has been partly crowdfunded via a campaign on Kickstarter.

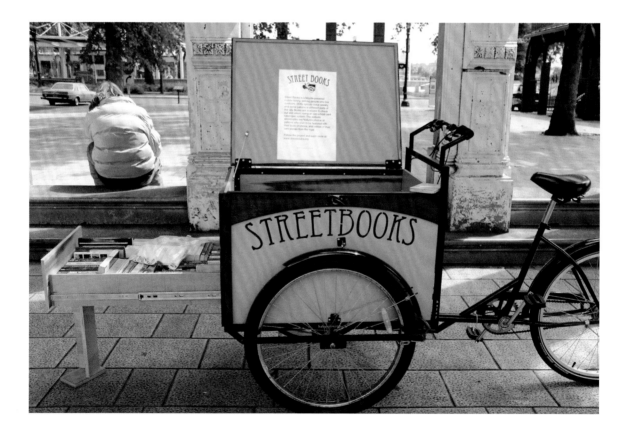

Uni Project pop-ups

This inviting outdoor reading room on Governors Island in New York Harbor was one of the Uni Project's most successful pop-up library locations. In collaboration with New York City's three public library systems – the Brooklyn Public Library, New York Public Library and Queens Library – it operated throughout the summer of 2013, offering children's programmes and educational activities as well as books for reading on site.

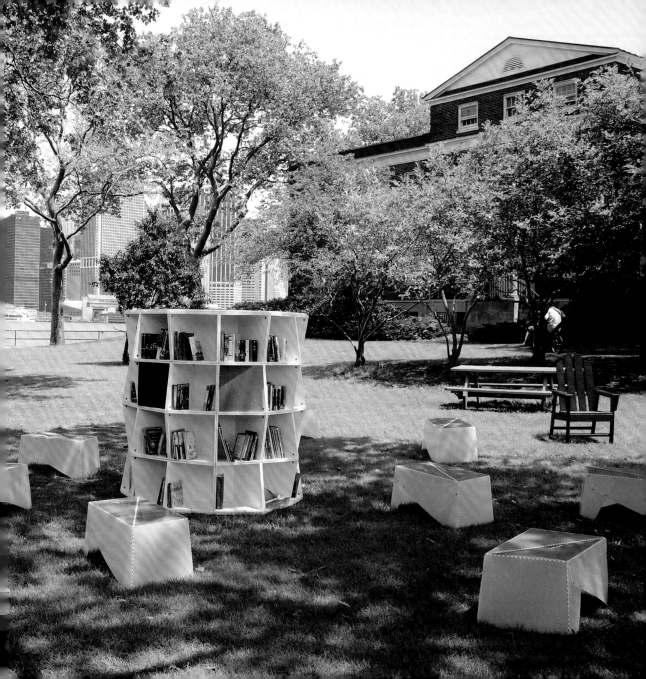

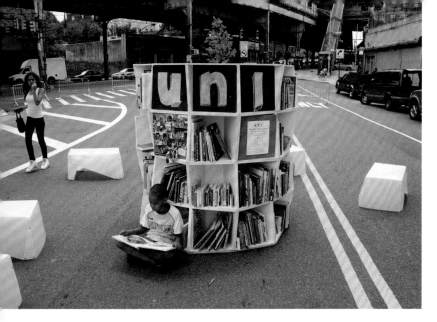

LEFT AND OPPOSITE
Uni pop-ups in the Bronx (left) and Corona Station, Queens (opposite). The Uni has set up nearly 200 temporary reading rooms around New York City in parks, plazas, festivals, sidewalks, and even one at the beach.

RIGHT
Uni also builds and ships mobile reading room kits to libraries and community organizations worldwide. In addition to its signature 360-degree case and stackable seating (shown above), Uni offers an unfolding plywood 'rock stage case' (right, shown in the project workshop) mounted on castors.

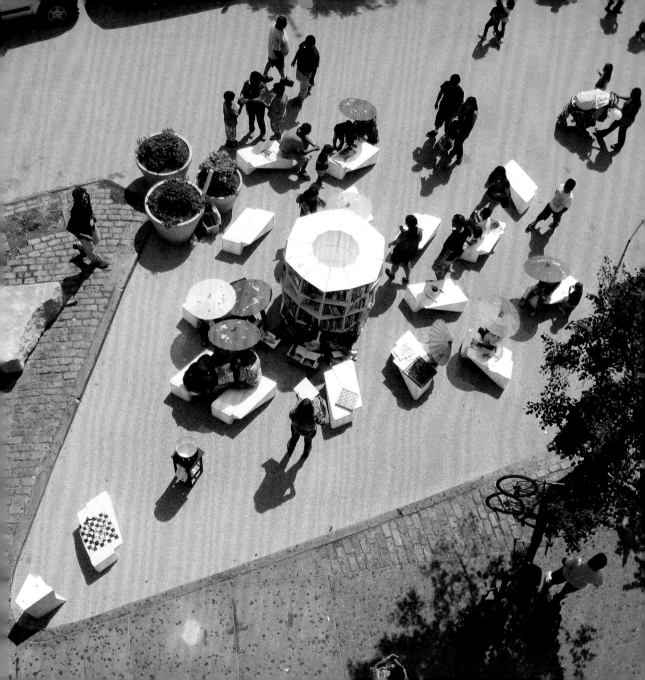

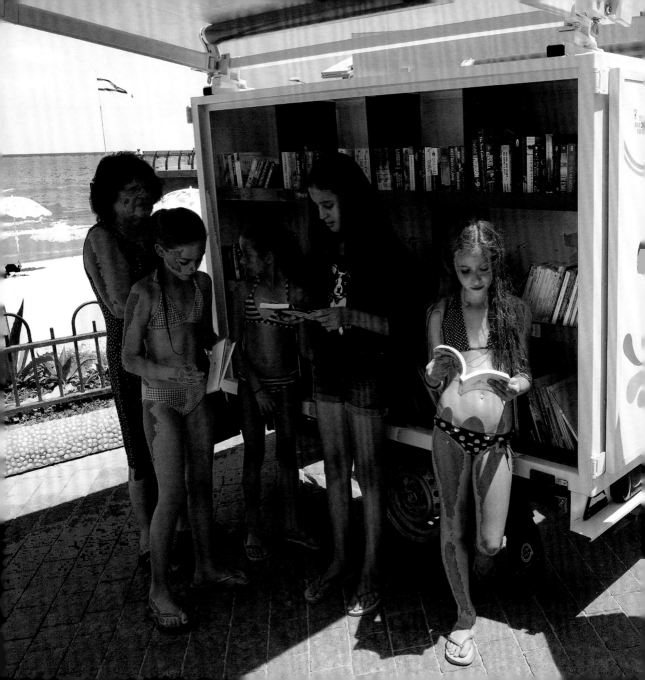

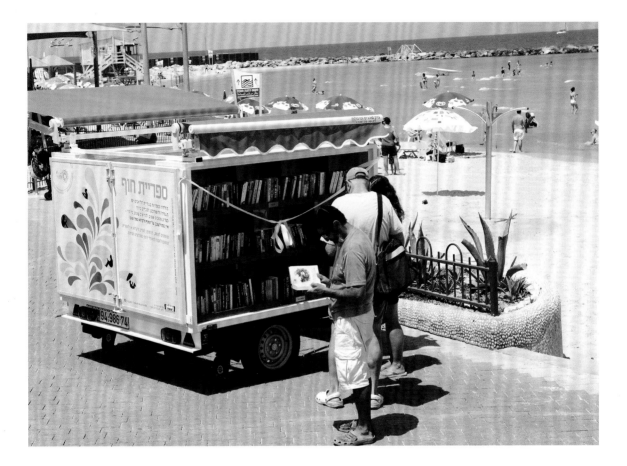

Books on the beach

After the success of the first beach
library in Tel Aviv's Metzitzim Beach
in 2013, three more were opened in
2014 at Jerusalem Beach, Gordon
Beach and Cliff Beach. The libraries
also have boxes where readers can
donate books to the collection.

Internet Archive Bookmobile

American entrepreneur Brewster Kahle's Internet Archive Bookmobile – sadly no longer running – gave the bookmobile concept a 21st-century flavour. Users browsed a digital library with a stock of 20,000 public domain books, which could be read onscreen or printed on the spot with a portable Print On Demand machine.

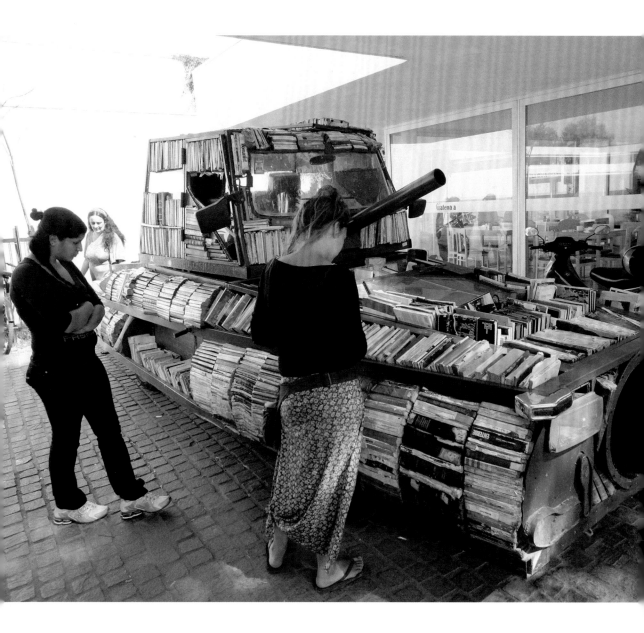

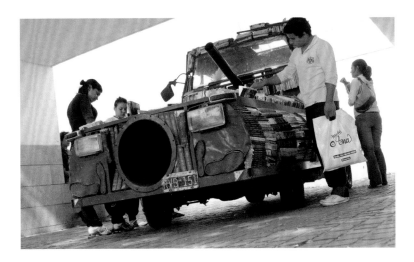

Weapon of Mass Instruction

Activist and artist Raúl Lemesoff has turned a military-surplus 1979 Ford Falcon into a tank-like vehicle that he calls the Arma de Instrucción Masiva ('Weapon of Mass Instruction'). He drives it around Buenos Aires offering books to passersby, and has plans to extend its reach to Peru and Bolivia.

Lemesoff describes his tank-library as a mobile sculpture, and says that the aim of the project is to 'contribute to peace and understanding of peoples'.

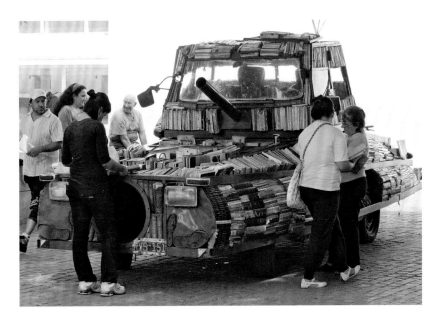

7.
Not
Libraries

Some of the most interesting libraries aren't, strictly speaking, libraries at all. They are collections of reading material lent from spaces that primarily serve another purpose: shops, parks, pubs or cafés – even prisons. Despite their unlikely surroundings, however, all do an excellent job of supplying books and other materials to a wide readership.

Cafés have a long history of offering customers books. Historian Markman Ellis has shown that in mid-18th-century London coffee houses provided drinkers with impressive amounts of reading material, which included not only newspapers, but also the latest books of poetry, satire and philosophy, along with political pamphlets and business guides. Carrying on that noble tradition, the Rowntree Park Reading Café in York, England, located on the south side of the park, operates as an informal branch of the city's library service. Visitors can borrow from the café's stock of around 1,000 volumes, or return or order books as they would in other library branches. Newspapers, magazines and free Wi-Fi are also available, as are pleasant views of the River Ouse from the balcony.

Similarly, some traditional British pubs house public library branches. Two rural Cornish pubs have teamed up with Cornwall Council's library service to provide community libraries for local residents. The Star Inn in Vogue, run by Mark and Rachel Graham, and the Ship Inn in Lerryn, run by ex-city stockbrokers Ronni Collins and John Pusey, both house Community Libraries, set up in collaboration with campaigning organization Pub is The Hub, which helps rural British pubs to diversify their services for the benefit of their communities. As in a traditional library, pubgoers can either borrow the books on the shelves or reserve titles from other libraries in Cornwall, using the computer provided.

The truth is that anywhere people gather has the potential to be a library location. Parks, for instance, have long been popular sites for open-air 'not libraries'. The Bryant Park Reading Room, which opened in New York City in 1935 to serve homeless jobseekers during the Great Depression, was one of the earliest such projects. Similar libraries featured elsewhere in this book include the Garden Library in Levinsky Park in Tel Aviv (pp. 26–27), and Colombia's Paradero Para Libros Para Parques initiative (pp. 78–79). Retail shops – even those without obvious literary connections – were once surprisingly common locations for libraries. In the US, for instance, many of the large supermarkets that proliferated after the Second World War offered both self-service and fully staffed libraries to attract customers.

Library director D. Robert Alvarez helps a shopper take out a book from one of the Nashville Public Library's Booketerias, this one housed in a Logan supermarket in Belle Meade, Tennessee, 1953.

In the UK, the earliest 18th-century circulating libraries were often connected to clothes shops. London's famous subscription library Mudie's was originally a stationery shop; stationer and bookseller W. H. Smith operated a similar scheme. The chemist chain Boots operated one of the most successful, its Booklovers Library. The first was set up in 1898; by 1920 there were over 150 branches and more than 500,000 members, rising to in excess of a million during the Second World War. The libraries themselves were usually on the first floor or at the back of each shop; bigger

locations in Manchester, Glasgow, Edinburgh and Brighton offered comforts such as sofas, window seats and fresh flowers. Books could be borrowed and returned to any branch. Sadly, the last Boots library closed in 1966.

Shoppers still clearly have an appetite for libraries: the Bondinho da Leitura in Curanaba, Brazil, for example, serves shop-weary customers from a static former tram in the city's largest pedestrianized retail district. In an equally ambitious conversion, design firm studio 8½ has turned a trolley bus into a static library in a public square in Plovdiv, Bulgaria, installing carpeting and imaginatively designed shelving that holds more than 600 books by Bulgarian and foreign authors. Furniture retailer IKEA, however, set up its library away from the shops, with a temporary (though fully functional) installation of bookshelves on Bondi Beach in Australia to commemorate the 30th anniversary of the company's popular 'Billy' bookcase model.

In recent years, artists have also delighted in exploring how the essence of a library might be presented afresh in unexpected surroundings. These temporary library–art installations, all open to the public, have ranged from a giant tree house in London's Regents Park to an elaborate wooden structure inside the ruins of an ancient bathhouse in Plovdiv,

Bulgaria, and even long rows of library bookshelves in the vineyard of a former monastery in Ghent in the Netherlands. Although not a functioning library, a similar statement is made by Adam Dant's elaborate installation, in a gallery in a former water pumping station in South London, of an Enlightenment-era library made constructed from painted canvas and chicken wire.

Perhaps the most extreme modern incarnation of the 'not library', however, is the prisoners' library at the American-run Guantanamo Bay detention centre in Cuba, where immaculately catalogued library shelves, whose subject labels feature cheerful cartoon bookworms, store reading material behind barbed wire, electrified fences and hi-tech security doors.

A Boots Booklovers Library in Southampton, England, c. 1905, and a customer leaflet, c. 1940.

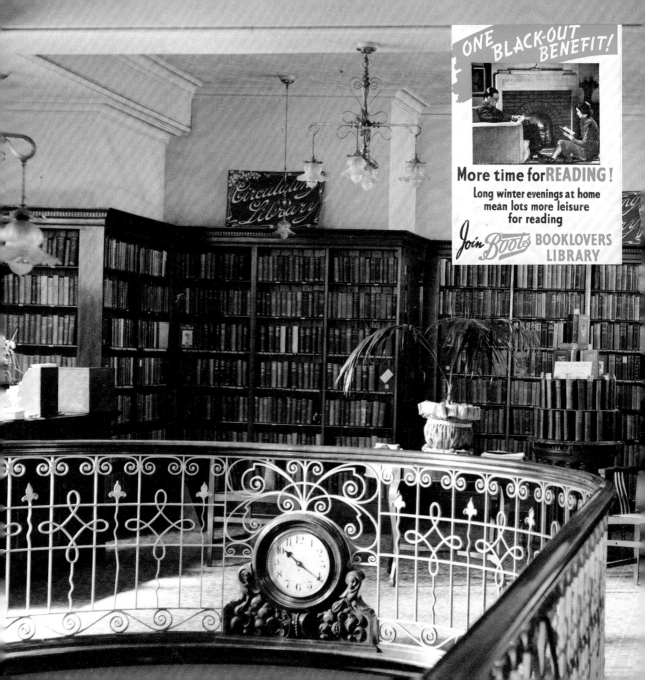

Circulating
Library

Books behind bars

The Harry Potter series, Agatha Christie mysteries and *The Lord of the Rings* have been among the most popular titles at what is probably the most high-security library in the world, serving inmates at the notorious US-run Guantanamo Bay detainment camp in Cuba. The library stocks around 20,000 books, mostly in Arabic and English, along with a selection of magazines.

ABOVE AND OPPOSITE
The books and periodicals are shelved by subject in a prefabricated 'library' building (above), but prisoners are not permitted to browse the stacks. Titles must be ordered by inmates in advance, or selected from a book box that a librarian carries from cell to cell once a week (opposite). Each book is carefully checked after it is returned to prevent inmates passing messages to each other.

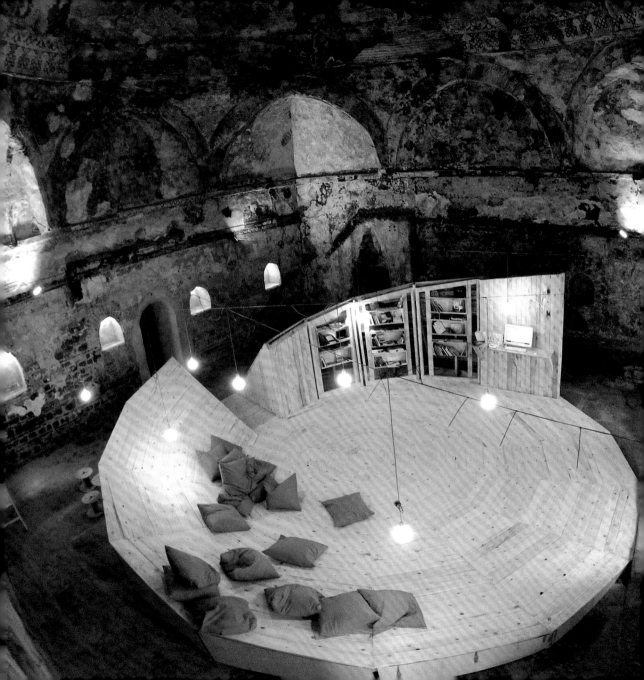

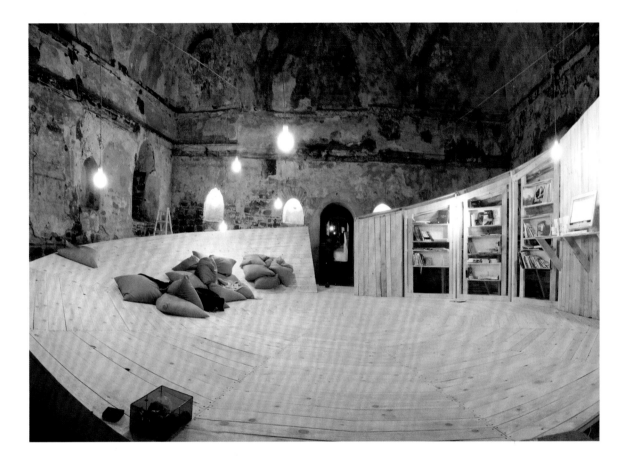

Reading in the bath

The wooden |CON|Temporary library was
created by studio 8½ to showcase books
on contemporary art for the Centre for
Contemporary Art and Architecture in
Plovdiv, Bulgaria. The stand-alone temporary
structure was installed in an abandoned 16th-
century Turkish bathhouse. It incorporates
shelving, a computer for viewing video
materials, and a half-spiral, gently sloping
floor with comfy pillows for seating.

Library of Dr London

The Library of Dr London was an art installation by Adam Dant featuring a faux Enlightenment library set up in 2010 at the Pump House Gallery in London's Battersea Park. The trompe l'oeil book titles and gilded shelf plaques construct an extended metaphor of the city as human body, with each district corresponding to an organ or system.

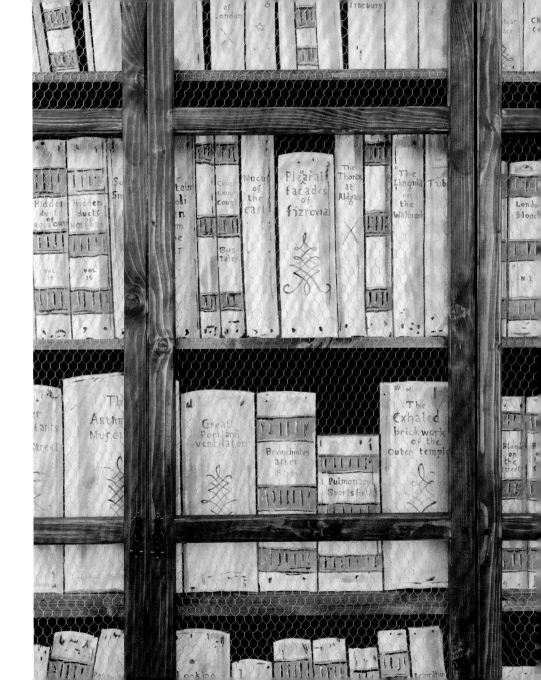

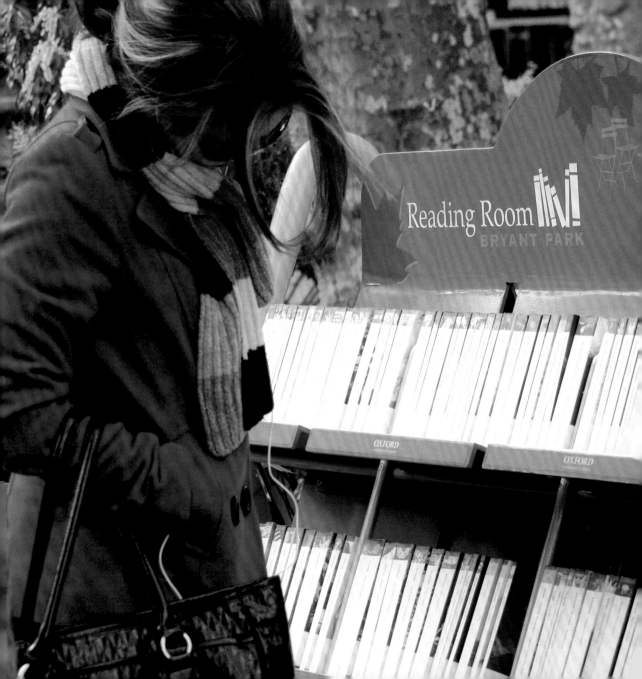

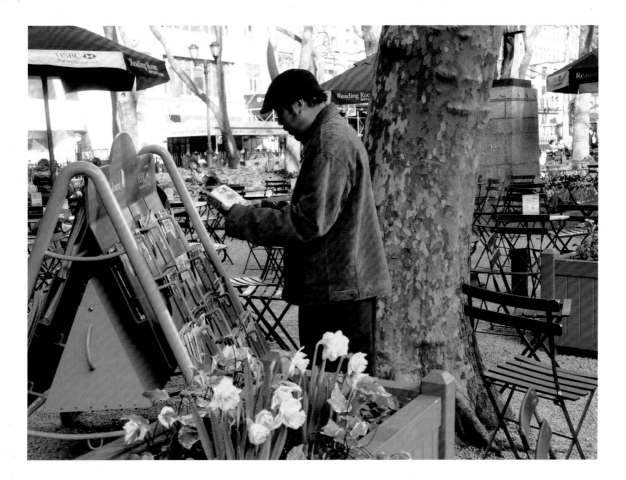

Books in the park

The Bryant Park Reading Room was first
set up in New York City in 1935 to provide
library services for the unemployed. It
closed in 1944 but has been re-established
using specially built carts to carry books and
magazines. A lunchtime readings programme
and facilities for children are also offered. The
library is still free, and still does not require
any kind of membership card or identification.

Books on tap

The pub libraries at the Star
Inn (these pages) and the Ship
Inn (overleaf) in Cornwall,
England, were put together
for less than £1,000 each, which
included shelving, signage and
a computer terminal to link the
libraries to the main library
service network.

Landlady to librarian

Ronni Collins, landlady at the Ship Inn in Cornwall, hopes that the library will encourage more women to visit the pub, as well as pulling the village community together.

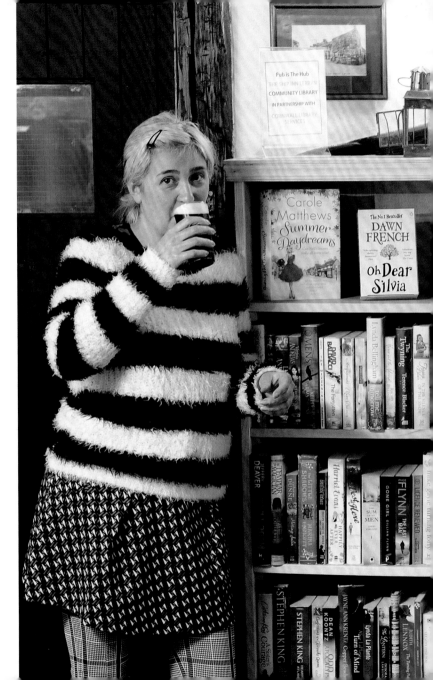

Street library

The Mighty Writers project in Philadelphia
– which promotes children's literacy through
after-school clubs – has perhaps the simplest
of library arrangements: tables of donated
books are set up on the pavement outside
its three city-centre locations. Children and
adults are encouraged to take books home
and build their own libraries.

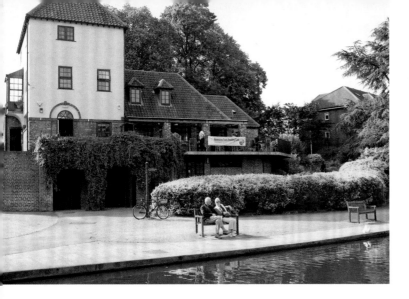

Reading Café

The Reading Café – formerly
the park-keeper's lodge – at
Rowntree Park in York, England,
has a particularly good stock
of children's books as well as
a monthly knitting group.

Bondinho da Leitura

This static former tram in the pedestrianized Rua XV de Novembro shopping district in Curitiba, Paraná, Brazil, was redeveloped in 2010 as a free library by the Curitiba Reads programme, open to city residents with ID. Shoppers and passersby of all ages can peruse and borrow the tram's 2,500 volumes, which include classics of Brazilian and world literature as well as the latest bestsellers.

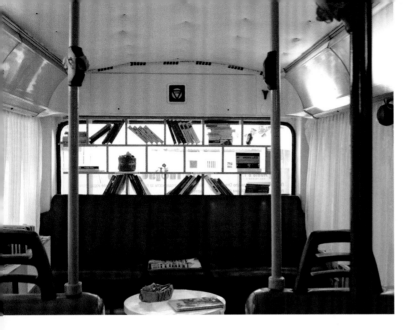

Book trolley

'The project offers a new life for a small city square,' says Vladislav Kostadinov of his static trolleybus library in Plovdiv, Bulgaria. 'This library will fill a gap formed by the lack of cultural centres nearby.'

Kostadinov has attempted to retain as much of the trolleybus atmosphere as possible, including the original seating, handrails and bell buttons for alerting the driver. The library also features unusual shelving techniques such as the use of clothes hangers.

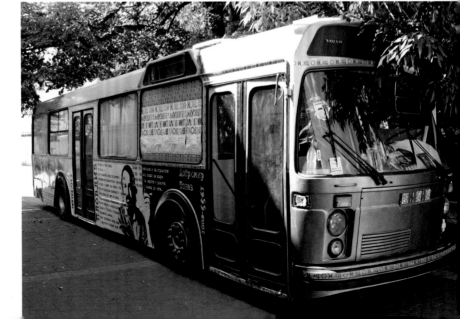

Bondi bookshelf

To celebrate the 30th anniversary of its iconic 'Billy' bookcase, IKEA set up the world's longest outdoor bookshelves on Bondi Beach near Sydney. Visitors were invited to swap their own book for one of the 6,000 on the shelves, or to make a small donation to The Australian Literacy & Numeracy Foundation.

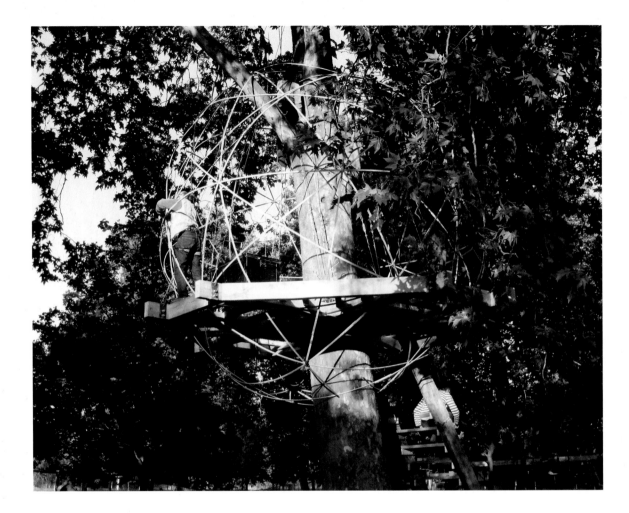

Local branch library

Part of a larger installation involving two giant treehouses in London's Regents Park in 2009, the Spherical Reading Gallery, designed by Claudia Moseley and Steph Smith, held several hundred books for arboreal adventurers to peruse.

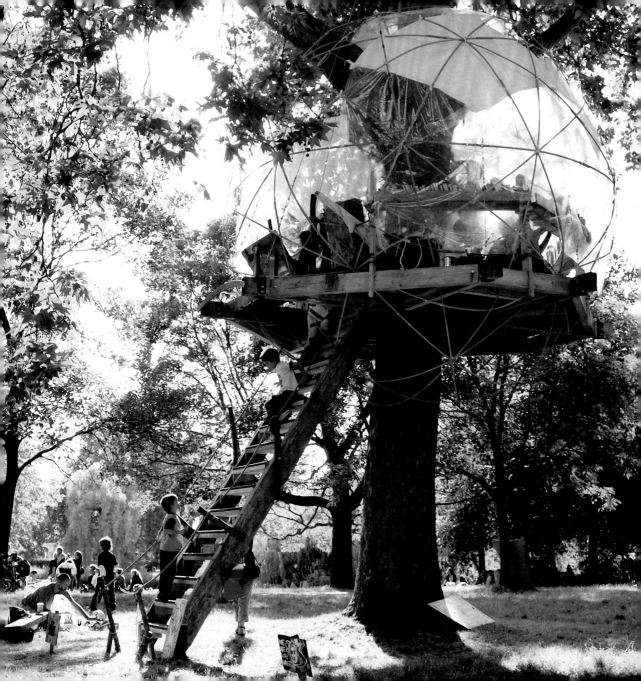

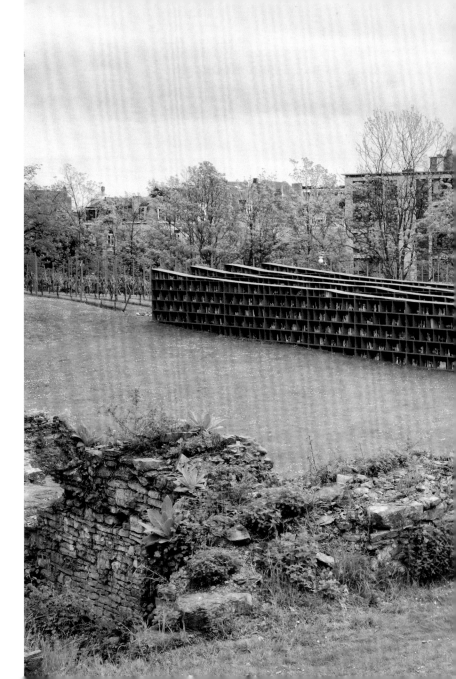

Bookyard

Artist Massimo Bartolini's
temporary installation
Bookyard in 2012 consisted of
a dozen rows of bookshelves
lined up with the rows in the
vineyard of St Peter's Abbey,
Ghent. Visitors were invited
to borrow the books, mostly
unwanted volumes from the
public libraries of Ghent and
Antwerp, or to donate their
own to the selection.

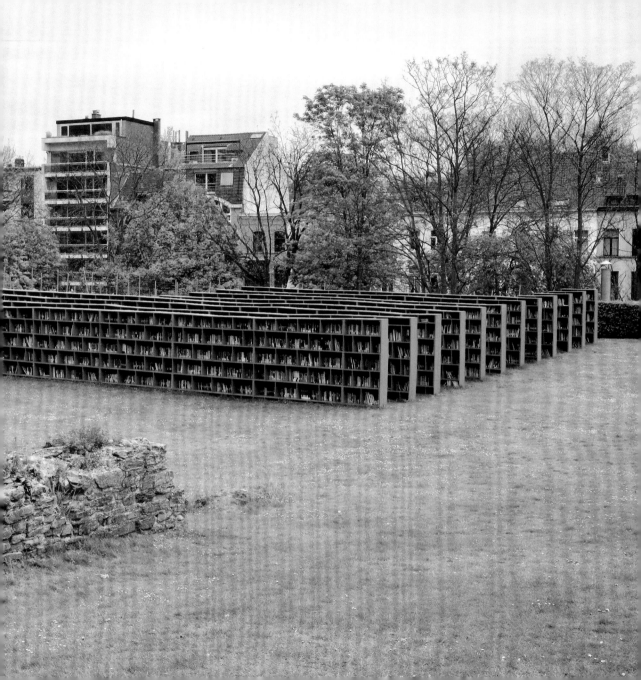

SELECT BIBLIOGRAPHY

Battles, Matthew, **Library: An Unquiet History**, W. W. Norton & Company, 2004

Belanger, Terry, **Lunacy and the Arrangement of Books**, Oak Knoll Press, 2003

Benjamin, Walter, **'Unpacking My Library'**, originally delivered as a lecture in 1931, repr. in *Illuminations: Essays and Reflections*, Schocken, 1969

Borchent, Don, **Library Confidential**, Virgin Books, 2007

Bosser, Jacques, **The Most Beautiful Libraries in the World**, Harry N. Abrams, 2003.

Borges, Jorge Luis, **The Library of Babel** (El Jardín de senderos que se bifurcan), Editorial Sur, 1941

Campbell, James, and Will Pryce, **The Library: A World History**, Thames & Hudson, 2013

Carley, James P., **The Books of King Henry VIII and His Wives**, British Library, 2004

Cleeves, Ann, et al., **The Library Book**, Profile, 2012

Darnton, Robert, **The Case for Books: Past, Present and Future**, PublicAffairs, 2010

Davis, David, **Librarian's Night Before Christmas**, Pelican, 2007

Dupuich, Dominique, and Roland Beaufre, **Living With Books**, Thames & Hudson, 2010

Eco, Umberto, and Jean-Claude Carrière, **This is Not the End of the Book**, Vintage, 2012

Ellis, Estelle, Caroline Seebohm, Christopher Simon Sykes and Clarkson Potter, **At Home with Books: How Booklovers Live with and Care for Their Libraries**, Thames & Hudson, 1995, repr. 2006

Ellis, Markman, **'Coffee-House Libraries in Mid-Eighteenth-Century London'**, *The Library: Transactions of the Bibliographical Society*, Vol. 10, No. 1, March 2009

Fadiman, Anne, **Marrying Libraries in Ex Libris: Confessions of a Common Reader**, Penguin, 2000

Geddes-Brown, Leslie, **Books Do Furnish a Room**, Merrell, 2009

Gladstone, William Ewart, **On Books and the Housing of Them**, MF Mansfield, 1898

Grant, Linda, **I Murdered My Library,** Kindle Single, 2014

Hamilton, Masha, **The Camel Bookmobile**, Harper Collins, 2007

Hammer, Bjarne, **Libraries**, Roads Publishing, 2014

Henshaw, Sarah, **The Bookshop that Floated Away**, Constable, 2014

Höfer, Candida, **Libraries**, Schirmer/Mosel, 2006

Jenner, Margaret, **Small Libraries of New Zealand**, Bay of Plenty Polytechnic, 2005

Johnson, Alex, **Bookshelf**, Thames & Hudson, 2012

Johnson, Arnold B., **'Lighthouse Libraries'**, *Library Journal*, February 1885

Johnson, Marilyn, **This Book is Overdue! How Librarians and Cybrarians Can Save Us All**, Harper Collins, 2011

Larkin, Philip, **'Shelving the issue'**, *New Statesman*, 10 June 1977, repr. in *Further Requirements*, Faber & Faber, 2013

Manguel, Alberto, **The Library at Night**, Yale University Press, 2008

Nixon, Howard M., and William A. Jackson, **'English Seventeenth Century Travelling Libraries'**, *Transactions of the Cambridge Bibliographical Society*, Vol. 7, No. 3, 1979

Orton, Ian, **An Illustrated History of Mobile Library Services in the United Kingdom: With Notes on Travelling Libraries and Early Public Library Transport**, Branch and Mobile Libraries Group of the Library Association, 1980

Orwell, George, **Books vs Cigarettes**, Penguin, 2008

Henry Petroski, **The Book on the Bookshelf**, Alfred A. Knopf, 1999

Polastron, Lucien X., **Books on Fire: The Tumultuous Story of the World's Great Libraries**, Thames & Hudson, 2007

Powers, Alan, **Living with Books**, Sterling, 2006

Rugg, Julie, **Buried in Books: A Reader's Anthology**, Frances Lincoln, 2010

Spufford, Francis, **The Child That Books Built**, Faber & Faber, 2003

Steffens, Jo (ed.), **Unpacking My Library: Architects and Their Books**, Yale University Press, 2006

FOR CHILDREN:

Buzzeo, Toni, **Inside the Books: Readers and Libraries Around the World**, Upstart Books, 2012

Cotton, Cynthia, **The Book Boat's In**, Holiday House, 2013

Ruurs, Margaret, **My Librarian Is a Camel: How Books are Brought to Children around the World**, Boyds Mill Press, 2005

ONLINE RESOURCES:

There are many visual collections online, especially on **Pinterest**, of beautiful and unusual libraries. Fewer sites take a more sociological look at the subject of non-traditional libraries, although **Treehugger.com** is an honourable exception. **Dezeen.com** and **Archdaily. com** present a wide selection of the more monumental modern libraries of recent years with numerous excellent illustrations.

Shannon Mattern's 'Marginalia: Little Libraries in the Urban Margins' at **http://places.designobserver.com/ feature/little-libraries-and-tactical-urbanism/33968** is a superb look at many of the issues raised by this book.

One of the best of the many articles written about the importance of libraries in the face of funding cuts is 'The secret life of libraries', by Bella Bathurst, *The Observer*, 1 May 2011, available online at **http://www. theguardian.com/books/2011/may/01/the-secret-life-of-libraries**

Larry Nix's site at **http://www.libraryhistorybuff. com** looks at many US library-related subjects such as libraries depicted on postcards and stamps.

Orty Ortwein's ongoing blog on bookmobiles at **http:// bookmobiles.wordpress.com** features a wide variety of mobile libraries.

There are useful blog posts on the importance of books and libraries in prisons at the Chartered Institute of Library and Information Professionals at **http:// www.cilip.org.uk/cilip/news/what-difference-do-prison-libraries-make** by Jacqueline May, and by Scott Pack at **http://meandmybigmouth.typepad.com/ scottpack/2014/05/books-in-prisons.html**

British Pathé has now put its film library online and features various intriguing videos of mobile librarians around the world at **http://www.britishpathe.com**

The Robert Dawson Library Project, a photographic survey of public libraries throughout the United States, is at **http://robertdawsonlibrary.wordpress.com/about**

All URLs accurate as of 15 September 2014.

ACKNOWLEDGEMENTS

My biggest thank-you naturally goes to all the librarians, artists and architects who have generously shared the details and photos of their work for this book. I also have the good fortune to be surrounded by many people, much cleverer than myself, with whom I regularly talk about the world of books, including: Sarah Salway, Celia Brayfield, Scott Pack, Emma Townshend, Andrew Wilcox, Adrian Murdoch, Jonathan Meres, Ian Beck, Lucy Inglis, Chris Routledge, Victoria Buckley, Suw Charman-Anderson and Ben Locker. It has also been a delight to work again with the clever and hardworking team at Thames & Hudson, and with the book's designer, Karin Fremer.

AUTHOR BIOGRAPHY

ALEX JOHNSON is an English journalist who works for *The Independent* and is also an editorial consultant for several charities. He blogs at *Bookshelf* (http://theblogonthebookshelf.blogspot.com) and *Shedworking* (http://www.shedworking.co.uk), both of which have been published as books, most recently *Bookshelf* (Thames & Hudson, 2012). Both his parents are librarians. Alex's favourite libraries are the Radcliffe Camera and the Queen's College's library in Oxford. After stints in York, London and Madrid, Alex now lives in St Albans, Hertfordshire, with his wife and three children.

PHOTO CREDITS

1 Luis Gallardo/ PRODUCTORA; **2** Bonnie Alter; **6** Bibliothèques Sans Frontières/Libraries Without Borders; **9** Shaharaine Abdullah; **10** Kristian Kearns; **13** David Shankbone; **17** Photo Wallace Kirkland/Time & Life Pictures/ Getty Images; **22** Ferrocarrils de la Generalitat de Catalunya; **23** Ayuntamiento de Madrid; **24–25** Sistema Nacional de Bibliotecas Públicas Chile; **26** T. Rogovski; **27 above** R. Kuper; **27 below** Rogovski; **28** Easytaxi; **29** Keri Tan; **30** Sander Stoepker/ProBiblio; **31** Free Library of Philadelphia; **32–33** Erik Törnkvist, ETAT ARKITEKTER AB; **34** Sander Stoepker/ProBiblio; **36–39** Boris Zeisser/24H-architecture; **40** Library Hotel, New York; **41** Ultimate Library; **42** The Library, Koh Samui; **44–45** Gladstone's Library; **46** NoMad Hotel; **47** Radisson; **50** Western Maryland Regional Library; **51** Goodman-Paxton photographic collection/University of Kentucky Digital Library; **54–55** Luis Soriano; **56–57** Universidad Valle del Momboy; **58–59** Jambyn Dashdondog/Mongolian Children's Culture Foundation/Go Help; **60–61** Cien Keilty-Lucas/Ethiopia Reads; **62–63** Big Brother Mouse; **68** Little Free Library; **70–71** Didier Muller/House Work; **72–73** Bonnie Alter; **74–75** Claudia Cooley; **76–77** Baufachfrau; **78–79** Fundalectura/IBBY Colombia; **80–81** Hannah Airey/Gap Filler; **82–83** Peter de Wit; **84–87** Eirini-Aimilia Ioannidou/Eleftherios Ambatzis; **88–89** Marta Wengorovius/João Wengorovius; **90–93** Little Free Library; **94–95** Marcelo Ertorteguy and Sara Valente/Stereotank; **96–97** Chloë Leen/Theodore Molloy/Thomas Randall-Page/Tõnu Tunnel; **98–99** John Locke; **100–101** Seung Teak Lee/ Mi Jung/Andrew Ma/stpmj; **102–3** Kniho Budka: Pavel Zelezny/ Monika Serbusová; **107** Seikei University; **110–13** Andreas Meichsner/ff-Architekten; **114–15** NHDM/NahyunHwang + David Eugin Moon; **116–17** Thomas Voelkel; **118–23** Christian Richters/Mecanoo; **124–25** Sou Fujimoto Architects; **126–27** BC architects; **128** National Library Board, Singapore; **130–33** Adam Mork; **134–35** Dimensional Innovations; **138** E Chaya; **140–41** Zhonghai Shen /ARCHI-UNION ARCHITECTS; **142–43** Design: Trout Studios; Photo: Hester & Hardaway; **144–45** Huh Juneul; **146–47** Jose Carlos Francisco Baeza/Judith Francisco Baeza; **148–49** Travis L. Price III www.TravisPriceArchitects.com/ Photographer: Ken Wyner; **150–51** Thomas Mandrup-Poulsen; **152–53** Daici Ano/Nendo; **154–57** Mjölk architekti/Barbora Kuklíková; **158** Ben Couture/3rdSpace; **163** shipwrecklog.com; **167** Photo Wallace Kirkland/Time & Life Pictures/Getty Images; **168–69** Asialink/Georgia Hutchison/Rob Sowter/ Soumitri Varadarajan; **170–71** Sarah Peters; **172–73** Ingrid Dræge/Bokbåten Epos; **174–75** Mohammed Rezwan/ Shidhulai Swanirvar Sangstha; **176–79** Karolina Zilliacus/Pargas; **180–82** Alexander Robb-Millar/Community Learning International; **184–85** Oswaldo Gutiérrez Tobón; **186–87** Luis Gallardo/ PRODUCTORA; **188** Henrique Boney; **189** The Seattle Public Library; **190** Pima County Communications Dept; **192–93** Jodi Darby; **194–97** Sam Davol/The Uni Project; **198–99** Israel Melovani/Tel Aviv-Yafo Municipality; **200** Brewster Kahle; **202–3** Guillermo Turin/Secretaría de Cultura y Educación, Municipalidad de Rosario; **207** Wiles-Hood/Nashville Public Library; **209** Alliance Boots Archives; **210** Emily J. Russell; **211** Patrick Thompson; **212–13** Vladislav Kostadinov/studio 8 ½; **214–15** Adam Dant; **216–17** Bryant Park Corporation; **218–20** Toby Weller/Pub is The Hub; **222–23** Maggie Leyman/Mighty Writers; **224** Explore York Library Learning Centre; **225** Bruna Carvalho; **226–27** Vladislav Kostadinov/studio 8 ½; **228–29** One Green Bean; **230–31** Claudia Moseley/Stephanie Smith; **223** Dirk Pauwels; **235** John Locke; **240** Miler Lagos

Book home
Colombian artist Miler Lagos's gallery installation
Home, 2011, is a self-supporting dome constructed
of stacked former library books.